404281076

A WINTERTHUR GUIDE TO
CHINESE EXPORT PORCELAIN

A WINTERTHUR GUIDE TO
CHINESE EXPORT PORCELAIN

Arlene M. Palmer

A Winterthur Book/Rutledge Books
Crown Publishers, Inc.

Cover Illustration: Figure 3.

Abbreviations Used in the Captions:

acc. no. = accession number
Ca. = circa
Diam = diameter
ex coll. = from the collection of
OD = overall diameter
OH = overall height
OL = overall length
OW = overall width

Prepared and produced by Rutledge Books, a division of Arcata
Consumer Products Corporation, 25 West 43 Street, New York,
N.Y. 10036.
Published by Crown Publishers, Inc., One Park Avenue, New York,
N.Y. 10016. Published simultaneously in Canada by General
Publishing Company, Ltd.
First printing 1976
Printed in the United States of America

Library of Congress Cataloging in Publication Data
Palmer, Arlene M
 A Winterthur guide to Chinese export porcelain.

 "A Winterthur book/Rutledge."
 Bibliography: p. 28.
 1. China trade porcelain. 2. Henry Francis du Pont
Winterthur Museum. I. Henry Francis du Pont Winterthur
Museum. II. Title.
NK4565.5.P34 1976 738.2'0951'07401511 76-10848
ISBN 0-517-52178-4 paper
ISBN 0-517-52784-7 cloth

Contents

Preface

Like the porcelain collectors of the eighteenth century, Henry Francis du Pont had a "passion for old china." Between 1925 and 1951, when Winterthur was opened as a museum, he acquired five thousand examples of Chinese porcelain made for the European and American markets. Gifts and purchases made over the past twenty-five years have helped to fill the very few gaps that remained in this outstanding collection.

This book consists of representative examples from the Winterthur collection that have been selected and arranged to present a general introduction to the subject of Chinese export porcelain. Since the dating of these porcelains has always been controversial, I have based my opinion wherever possible on related documented objects; in general, I have followed the lead of the most recent scholars in the field. In order to eradicate the misleading term "Oriental Lowestoft" from the literature of China trade porcelains, it seems necessary to mention here that the Lowestoft factory, a small soft-paste porcelain company in England, was in no way responsible for the manufacture or decoration of the wares we now recognize as true Chinese porcelains sent to the West.

I am grateful to David Sanctuary Howard, whose infectious enthusiasm for Chinese export porcelain sparked my interest and led to this study. Virtually all the information about the armorial porcelains at Winterthur was supplied by Mr. Howard. Others who generously contributed their time and knowledge are Josephine Hadley Knapp, Freer Gallery of Art; Clare Le Corbeiller, The Metropolitan Museum of Art; and Matthew and Elisabeth Sharpe, Conshohocken, Pennsylvania. Finally, my thanks go to my colleagues at the Winterthur Museum for their cooperation and assistance in the typing and editing of the manuscript, and the photography for the book.

Arlene M. Palmer

Introduction

What ecstasies her bosom fire!
How her eyes languish with desire!
How blest, how happy should I be,
Were that fond glance bestow'd on me!
New doubts and fears within me war:
What rival's near? a China *jar.*

China's the passion of her soul;
A cup, a plate, a dish, a bowl
Can kindle wishes in her breast,
Inflame with joy, or break her rest.
John Gay, 1725

Chinese porcelain was the delight, if not the passion, of Europe's soul in the eighteenth century. More than 60 million pieces of porcelain reached the West before 1800, creating and filling a need for tablewares and ornaments and stimulating European production of imitative ceramics. Yet, as Gay suggests, the allure of porcelain went beyond mere practical concerns to an emotional level. Travel books acquainted the Westerner with the East, but goods imported from the East gave him a firsthand experience. As symbols of "the most remarkable of all countries yet known," [1] a country that few had actually seen, the creations of the Chinese potters never ceased to fascinate.

The few porcelains owned in Europe before 1600 were treasured as emblems of great wealth. One Frenchman noted the great value attached to porcelain: "The most expensive salads, fruits, and preserves count for nothing if they are not served in porcelain. . . . Popes, kings, emperors, dukes, Italian marquises . . . follow this custom." [2]

When porcelains became more common, in the seventeenth century, "china collecting" became a favorite pastime. Daniel Defoe remarked in the 1720s that Queen Mary II had

brought in the Custom or Humour, as I may call it, of furnishing Houses with *China*-Ware, which increased to a strange degree afterwards, piling their *China* upon the Tops of Cabinets, Scrutores, and every Chymney-Piece, to the Tops of the Ceilings, and even setting up Shelves for their *China*-ware where they wanted such Places. [3]

Rooms designed for the display of porcelain were carried to the greatest extreme by the German princes, whose "porcelain rooms" not only exhibited individual objects but also incorporated porcelain into architectural elements. Augustus the Strong of Prussia, the most ardent collector, planned a "Japanese Palace" in which each room was to be decorated exclusively with porcelain.

In spite of the enthusiasm of such collectors, the trade in Chinese porcelain would not have survived had there not been a broadly based, practical demand. The introduction to the West of tea and, to a lesser degree, coffee, stimulated popular demand for porcelain. Although the first tea in Europe was brought to Holland in 1610, it did not become a popular drink until later in the century. Costly, but "by all Physitians approved," tea became the standard beverage for Englishmen of all classes. [4] (It was somewhat less popular on the Continent where coffee and chocolate were strong competitors.) To prepare this tea required a sturdy vessel made from a substance that would not spoil the tea's flavor. Porcelain, preferred by the Chinese, was the obvious choice.

Europe's "China-mania" extended beyond a vogue for Oriental manufactures and customs. The rococo style that permeated Western art of the 1720−60 period promoted Europe's already idealized vision of the East and led to the adoption of Chinese motifs in everything from landscape design to textiles. The Chinese painter's preoccupation with nature as well as his style— asymmetrical and unhampered by rules of perspective—appealed to those who had found baroque classicism too restrictive. The *chinoiserie* movement was strongest on the Continent, but it had advocates—and critics—in England. John Brown, for example, deplored "every gaudy Chinese Crudity, either in Colour, Form,

Attitude, or Grouping [that has been] adopted into fashionable use, and become the Standard of Taste and Elegance." [5]

Chinese porcelain had, perhaps, the most enduring influence of all exotic imports because of the challenge it offered to the European ceramic industry. Although the tin-glazed earthenwares (delft, faience, majolica) were porous and opaque, tin oxide added to the lead glaze afforded a smooth, white surface that could be decorated to resemble Chinese porcelains. Successful efforts to produce a translucent, hard white substance date from the Medici factory of the late sixteenth century. Unfortunately, the formula was lost, only to be rediscovered a century later in France. However, even this substance, as well as the so-called soft-paste porcelain made in eighteenth-century Europe, was not the "true" porcelain of China. Its body was softer, and its glaze was thicker than the skinlike coating of Chinese ware. A porcelain comparable to the oriental product in all respects was first perfected at Meissen in 1708, and the formula was eventually duplicated elsewhere in Europe. In spite of this technical achievement, European potteries could not match the incredibly low cost of Chinese export wares until the last quarter of the eighteenth century.

The China Trade

Direct trade between Europe and China began in 1517 when Manuel I of Portugal dispatched an embassy to Peking. Vasco da Gama had navigated around the Cape of Good Hope some years before, and the spices, silks, and porcelains he brought back from the Orient revealed the potential of Eastern trade. The first Portuguese connection lasted only four years, but the earliest porcelains designed for export to the West may date from that brief period. [6] Only in 1557 were Portuguese merchants permitted to establish a permanent trading base at Macao, some eighty miles south of Canton, although some illicit trafficking had occurred in the interim.

The Portuguese traders were more interested in carrying Chinese goods to other parts of the Eastern world than in exploiting the European market for oriental goods. However, the porcelains that they did ship to Lisbon made that port the major source of porcelains for most of the other European nations in the sixteenth century. When, in 1595, that port was closed, these nations were forced to seek their own routes to the East. By that time, Spain had gained access to Chinese wares through its position in the Philippines, and the success of a joint English-Dutch venture at the turn of the century led to the formation of the English East India Company in 1600 (Figure 1) and its Dutch counterpart, the Vereenigde Oestindische Compagnie (VOC), in 1602. Although spices were the original focus of Dutch expeditions, the capture of two Portuguese ships laden with porcelain, and the subsequent sale of these wares in Amsterdam in 1604, greatly increased Dutch interest in porcelain. The VOC went on to usurp the Portuguese position in the East, and by 1657 it had shipped more than 3 million pieces of porcelain to Europe. Political upheavals in China virtually stopped all trading between the years 1657 and 1683; the porcelain kilns at Ching-te Chen were, in fact, destroyed. To cater to the porcelain market in the interim, the Dutch opened trade with Japan and carried the porcelains of that country to Europe.

English interests in the Far East centered in India, not China, in the seventeenth century. After Canton was opened to foreign traders in 1699, however, the English turned their attention to China, and by 1708, the East India Company (a second organization) was in a position to dominate the trade. Between 1708 and 1802, the British undertook 790 voyages to Canton. British supremacy in the China trade was surpassed only in the nineteenth century by the Americans, whose first ship to the Orient, *Empress of China*, arrived at Canton in 1784. Other European nations, such as France, Denmark, and Sweden, also developed commercial relations with the Chinese, but their interests were intermittent and never equalled those of the Dutch or the English. French influence, however, was strong because of the positions held by French Jesuits at the Imperial Court since the seventeenth century.

Throughout the entire period, teas, spices, and silks formed the heart of the China trade, but only the durable porcelains have survived to suggest the extent and nature of the trade. In the sixteenth and seventeenth centuries, European vessels traded along the China coast for porcelains made at provincial kilns, such as the crude blue and white and celadon-glazed "Swatow" ware and the all-white *(blanc de chine)* products of the kilns near Te-hua. After 1757, however, foreign trade was restricted to Canton, and export porcelains were almost exclusively supplied by the potteries at Ching-te Chen, five hundred miles away in the province of Kiangsi.

Ships of the trading nations would leave Europe in January or February and arrive in China during the summer months. From Macao, they would sail up the Pearl River to anchor at Whampoa, where cargoes were transferred to junks and ferried the twelve miles to Canton. Each nation had its trading office ("factory") at Canton among the business houses (Hongs) of the Chinese merchants who controlled the export trade. The "factories" were confined to an area less than a quarter of a mile long along the bank of the river (Figures 2 and 3). All business had to be conducted within the Hongs and a few surrounding streets of shops (Figure

4). Indeed, before 1750, foreigners were permitted to reside in Canton only during the short trading season. Foreign women had to stay in Macao. An American supercargo (cargo officer) warned that "to carry a woman into China would produce your ruin!!!!!!!!" [7]

The Chinese strictly regulated the business of foreign merchants, who, in their eyes, were "uncouth beings full of unreasonableness and conceit." [8] Merchants told of the elaborate Chinese bureaucracy established to handle the trade and of the system of duties, fees, and gratuities exacted from Westerners. Presiding over the financial structure were the Hong merchants, selected from the most opulent merchants of Canton by the viceroy of the province. This group directed all foreign trade and was responsible to the government for the behavior of the "foreign devils." Individually, they transacted business with Western companies and accumulated great fortunes. A host of other officials were involved in the trade. As one American learned, "A Stranger . . . will find himself perplex'd & annoy'd beyond measure by the number of visits, applications & offers of service from the various descriptions of Chinese, such as Linguist, Comprodores, Servants, outside Speculators or Sharpers, China Street Shop Keepers &c &c . . ." [9]

The Hong merchants themselves handled tea purchases; for porcelains, foreigners turned to certain "unprivileged" merchants, men such as Synchong and Yam Shinqua (Figure 84), who procured porcelains and arranged for their decoration. Yam Shinqua even advertised his services in the *Providence* [Rhode Island] *Gazette*, May 12, 1804. Many orders were filled from stock in Canton, but if new shapes or special underglaze designs were desired, models and patterns had to be sent to Ching-te Chen. The order might be delivered the following season; even then, two years would elapse before the client in Europe or America received his goods. By the end of the eighteenth century, some china merchants in Europe and America had in their shops "sample" pieces illustrating a variety of stock border patterns from which customers could choose (Figure 5).

The Manufacture of Porcelain

Well into the eighteenth century, one of the main appeals of Chinese porcelain was the mystery of its manufacture. Unlike anything made in Europe, the white, translucent, resonant substance, named after the white cowrie shell, *porcellana*, generated a great deal of technical speculation. According to Marco Polo, the Chinese

> collect a certain kind of earth, as it were, from a mine, and laying it in a great heap, suffer it to be exposed to the wind, the rain, and the sun, for thirty or forty years, during which time it is never disturbed. By this it becomes refined and fit for being wrought into the vessels above mentioned [cups, bowls, dishes]. Such colours as may be thought proper are then laid on, and the ware is afterwards baked in ovens or furnaces.[10]

Later authors elaborated on this erroneous idea; Francis Bacon remarked in 1625 that porcelain was "a kind of plaster buried in the earth and by length of time congealed and glazed into that fine substance."[11] Others denied porcelain's mineral origin and, instead, claimed it was composed of eggshells, lobster shells, or the shells of periwinkles.

In fact, the Chinese made porcelain from two kinds of earth: a very pure white clay, known as *kaolin*, and a feldspathic stone called *petuntse*. Plastic and infusible, kaolin was considered the "flesh" of porcelain, while petuntse—the "bones"—provided translucence and resonance. Gathered in the mountains, these ingredients were carefully ground, washed, and refined. The creamy mass was "passed through a fine horse-hair sieve and then into [through] a bag made of two thicknesses of silk."[12] The ingredients were, shaped into small rectangular bricks to facilitate storage and shipment to the main porcelain-making center at Ching-te Chen.

Most common vessels were shaped on the potter's wheel. Jesuit Father d'Entrecolles, writing about Ching-te Chen in 1712, described the fashioning of a simple cup.

The first workman only gives it the required diameter and height, and it leaves his hands almost as soon as it is commenced . . . The foot of the cup is then nothing but a piece of clay of the necessary width, and it is only hollowed out with a knife when the other operations are finished, and when the cup is dry and firm enough. When the cup leaves the wheel it is taken by a second workman, who puts it straight upon its base. Shortly afterwards it is handed over to a third man, who puts it on its mould and gives its shape; this mould is mounted on a kind of wheel. A fourth workman trims and polishes the cup, especially the rims, with a knife, and pares it down as much as necessary for its transparency; he scrapes it several times and moistens each time, however little he may have pared it, if it is too dry, for fear he should break it. In taking the cup from the mould they turn it softly on the same mould without pressing it more on one side than the other otherwise it would develop cavities in the clay or it would go out of shape. It is surprising to see the rapidity with which these vessels pass through so many different hands; and I am told that a piece of fired porcelain has passed through the hands of seventy workmen. [13]

More complicated forms were either fashioned freely by hand or were pressed into molds. The Jesuit relates how special clay was used to take molds from the models, often in three or four parts. Relief designs were molded or achieved by trailing slip (liquid clay) or by applying freely modeled motifs (Figures 9 and 28). Intaglio decoration was carved with hand tools (Figure 12) or pressed into the clay with figured seals and stamps.

Even though unglazed porcelain is impervious to liquids after firing, each piece was carefully coated with a feldspathic glaze to create a smooth, lustrous surface. Body and glaze were generally fused in a single firing of at least 1250 degrees centigrade for three to four days. Early kilns were long, horizontal structures, but by the eighteenth century, they were replaced by tall, vertical structures, about six feet in diameter, with dome-shaped tops. Before firing, the porcelain objects were placed inside saggers (protective cases) that were stacked within the kiln. The quality of the product in large measure depended on its position inside the kiln and the kind of fuel that was used. As d'Entrecolles noted, "the

state of the weather instantly changes the action of the fire, the quality of the material it acts upon, and that of the wood which keeps it going." Sometimes "when they open the furnace they find the porcelain pieces and the cases reduced to a mass as hard as rock."

Although *blanc de chine* wares were popular export items (Figures 9 and 13), most Chinese porcelains were embellished with colors applied under the glaze, over the glaze, or in the glaze—depending on the nature of the colorant. Only oxides of copper (red) and cobalt (blue) could be painted directly on the air-dried greenware (unglazed body) and withstand the high temperature required to fuse glaze and body. Underglaze cobalt blue was more successful than copper red, and blue and white porcelains were of primary importance in the export trade. Blue-decorated porcelain was first made in the Ming dynasty, probably during the Yuan dynasty at the beginning of the fourteenth century, with the cobalt imported from the Near East, where potters had become skilled in its use. Depending on the purity of the cobalt and on the firing conditions, the blue and white wares of the Ming and Ch'ing dynasties (1368–1912) can range from gray blue to a rich violet (Figure 18).

Difficulties in firing copper red led to the introduction in the fifteenth century of an iron-oxide red enamel painted on previously glazed and fired wares and fused in a second firing at a lower temperature (Figure 15). This *rouge de fer* was the first step in the development of the overglaze enamel painting that characterizes better-quality export porcelains. Multifired enameled porcelains were more costly than the single-fired blue and white wares. Because of the disparity in temperature between the glaze firing (1250 degrees centigrade or more) and the subsequent enamel firing (800–900 degrees centigrade or less), enamels were simply fused to the surface and generally did not sink into the glaze as they did on the "artificial" European porcelains fired at a lower temperature.

During the reign of K'ang-hsi (1662–1722), designs were outlined in browns and blacks and then covered with translucent

enamels. Because greens predominated, the palette of that period has come to be called *famille verte* (Plate 1).[14] The other translucent colors were yellow, brown purple, a flat coral red, a fragile blue, and a composite black. While these enamels were usually painted on glazed and fired wares, they occasionally cover unglazed bodies (biscuit) and act as enamel glazes. They could also be applied to wares previously decorated in underglaze blue. The only shading or gradation of tone that was possible with these "hard colors" *(ying ts'ai)* was what could be suggested by the lines of the design beneath the enamel.

Western influence led to a completely new style of Chinese porcelain painting at the end of the reign of K'ang-hsi. Matteo Ripa, a painter and one of the Jesuit missionaries in Peking, reported to his superior in 1716 that the emperor had become "fascinated by our European enamels and the new method of enamel painting." [15] Imperial interest was such that European artists were dispatched to China to instruct painters in the preparation and application of the colors. This "new method" involved the use of opaque and semiopaque enamels of soft, rich hues, chief among which was a rose color (Plate 3; Figure 8). In the seventeenth century, Andreas Cassius of Leiden, The Netherlands, had developed this opaque enamel from colloidal gold. European enamelers of copper and gold quickly took up the rose and the other opaque colors *(famille rose);* their products bearing these "foreign colors," especially watchcases, were greatly admired in China. As early as 1687, the Jesuits requested enamels from Europe to give the Chinese as gifts. It is possible that the Orientals were equally familiar with German tin-glazed earthenware that featured the same pink-dominated palette. [16]

An opaque white, found on porcelains that can be documented to 1714, was the first new enamel mastered by the Chinese painters; the rose enamel is first found on porcelains made between 1720 and 1723. [17] Armorial services in *famille rose* enamels occur throughout the 1720s, but it is obvious from their uneven quality that the technique was not perfected until around 1730. The development of a white enamel was important because it

could be mixed with colored enamels to lighten and shade them, thereby providing a fuller range of color values. Other colors were mixed to provide an interesting variety of shades (Figure 45), while the black or brown lines, no longer visible through the opaque enamels, were sometimes added on top of the colors for detail. Some vessels made during the reign of Yung-cheng (1723–35) exhibit a mixture of translucent and opaque enamels, but by 1735 the old colors had clearly yielded to the new.

Imperial Chinese interest in foreign enamels led to the development of a vigorous Chinese industry of enamel painting. First centered in Peking, the craft later flourished in Canton, where enamel painters decorated blank or partially decorated porcelains according to the special orders of overseas customers. Enamel painting was certainly done at Ching-te Chen, but for how long is not known.

Western imports led to another technical innovation towards the end of the reign of K'ang-hsi: overglaze painting in a brown black, manganese-based ink (Figure 10). Flesh tints were occasionally added and the designs highlighted with gilt, but the style, called *encre de chine,* was essentially monochromatic and a stark contrast to the colorful *famille rose.* Occasionally, *encre de chine* is combined with the *famille rose* colors (Figure 75). Although the Chinese had a long tradition of calligraphic painting in ink, the impetus to adapt the technique to porcelain probably came from the collection of European engravings the Jesuit missionaries are known to have presented to the Emperor K'ang-hsi in 1712. The priests in this respect played an important role in the introduction of the *encre de chine* decoration and some of these porcelains featured Christian designs, but the term "Jesuit ware" often applied to black-painted ware is misleading. European subjects of a secular, even ribald, nature were copied in ink, while religious themes often occur in enamels (Figures 40, 42, 46, 48a, and 52).

As was the case with the opaque enamels, the *encre de chine* technique required considerable experimentation. In 1722, d'Entrecolles reported that the Chinese painters' attempts were unsuccessful, their ink tending to disappear in the firing. Within

eight years, however, they had solved such problems and were able to produce finely decorated wares for the European consumers. This period of development in the 1720s coincides with the perfection of black painting *(schwarzlot)* on Continental ceramics, principally at the du Paquier factory in Vienna and by independent German decorators. Some of these European ceramics—as well as actual engravings—undoubtedly served as models for the Chinese. *Encre de chine* was probably most fashionable between 1730 and 1750, but documented examples prove that it was made throughout the reign of Ch'ien Lung (1736−95). [18]

Overglaze enamels effectively highlight or complete a design painted in underglaze blue. Some export porcelains of the first half of the eighteenth century featured floral designs of iron-red enamel and gilt combined with underglaze blue (Plate 4). Known as "Chinese Imari," they were inspired by Japanese porcelains made in the kilns at Arita and exported from the port of Imari. Europe's demand for the red and blue Japanese wares probably led to the Chinese interest in making these imitative porcelains.

Colored glazes had long been a decorative technique of the Chinese potter. Porcelains coated with a brown glaze, first made in Ming times, became common export items in the eighteenth century. The high-fired ferruginous glaze ranged in color from a light tan to a dark chocolate. Sometimes the brown glaze surrounded reserve panels painted in *famille rose* enamels. In Figure 11, the brown glaze is uninterrupted on the exterior, but an Imari-style design fills the interior. Similar wares may have been owned by Mary Powel of Philadelphia, whose household inventory taken in 1759 included "6 brown china coffee cups and saucers enameled on inside," and "1 tea cup, 5 saucers, brown china flowered on inside." [19] Brown-glazed ware was sometimes called Batavian ware because much of it was shipped to the West from the Dutch post at Batavia on the island of Java.

It would probably not have occurred to the earliest European owners of Chinese export porcelain to alter their treasures in any way, except to set them in expensive metal mounts. But as the novelty of things Chinese diminished, and the technology of

enamel painting on ceramics improved, Westerners had no reservations about adding their own decoration. Some Chinese porcelains were sent abroad as blanks to be painted in the West, though it was cheaper for the East India companies to have Chinese painters execute their special orders. Yet much of this ware had some Chinese embellishment that the European decorators—and their customers—simply ignored. This is exemplified by a bowl painted in Holland with the bizarre "Wonder at Zaandam" scene (Figure 12). Clearly visible through the painting are a design flat-carved into the exterior surface of the bowl and underglaze blue borders. Likewise, a Chinese flower in the center is only partially obscured by the Dutch landscape. Other bowls are known that show seemingly identical Chinese decoration combined with Dutch designs of a related style. [20] Although practiced throughout Europe, the business of redecorating Chinese export porcelain was especially lively in Holland. As early as 1705, Gerrit van de Kaade opened a shop in Delft to sell only oriental porcelain that had been overpainted in Holland. Several examples date from the 1740s, but the fashion probably continued to the end of the century.

Forms for the West

Until the eighteenth century, relatively few China trade porcelains exhibit any concessions to European taste in form or decoration. Most export porcelains were purely oriental in character, as seen in the many blue and white wares included in Dutch still-life paintings of the seventeenth century. The exceptions are of interest, however, because they document the early phase of Chinese manufacture of Western forms. By the 1630s, when stable trade connections had been established, Dutch merchants requested and received with some regularity special forms designed to serve European needs and customs. In 1635, the VOC office in Amsterdam ordered, among other things, saltcellars, wide-rimmed dinner plates, and mustard pots, to be copied from wooden models. Other forms requested by the Dutch were beakers, barber bowls,

chalices, flowerpots, oil and vinegar sets, wine coolers, caudle cups, and chamber pots. [21] The modern dinner service evolved during the reign of K'ang-hsi; with an average of three hundred pieces, each service included everything from saltcellars to sauceboats. Special items ordered in the eighteenth century ranged from cane handles (Figure 15a), to watchcases (Figure 28), to dairy sets complete with strainers and spoons (Figure 26).

Because these forms were alien to Chinese life, the foreign customers had to provide the potters and painters with detailed instructions. The Dutch East India Company spelled out their 1639 order: the fruit plates were to be "without rim, with ridges like model 2," while the wine jugs were to be made "with spouts and without ridges as model 8." [22] From records and from the evidence of the objects themselves, it is apparent that European ceramics, glass, and metal forms were also shipped to China to be rendered into porcelain. A wall cistern made of faience was the prototype for a Chinese example (Plate 1), and European urns made of both pottery and porcelain inspired export porcelain copies (Figures 31 and 32). A rare porcelain goblet (Figure 33) was probably based on the same form in glass. The extraordinary monteith—a basin for cooling glasses—shown in Plate 2 was probably modeled after a metal sample sent to Ching-te Chen.

Occasionally, the foreigners placed unrealistic demands on the Chinese potters. D'Entrecolles observed that

European merchants demand sometimes from the Chinese workman porcelain slabs, to form in one piece the top of a table or bench, or frames for pictures. These works are impossible; the broadest and longest slabs made are only a foot across or thereabouts, and if one goes beyond, whatever may be the thickness, it will be warped in baking. [23]

Such frustrations were not new to the potters, however, who often received orders from the Imperial household that exceeded their technical capabilities. D'Entrecolles reported repeated failures to fashion a foot-high, fourteen-pipe mouth organ for the heir apparent.

The obvious difficulties of special-order porcelain were the

Chinese manufacturer's complete unfamiliarity with European ways and the lack of direct communication between him and the customer. As a contemporary Chinese author noted, the shapes of the "foreign pieces" were "usually very strange." [24] Even when the merchant took great care to see that the porcelains were fashioned to his client's expectations, misunderstandings were bound to occur. The *blanc de chine* mug of Figure 13 seems a faithful copy, in form, of European mugs of stoneware, tin-glazed earthenware, silver, and glass—except for the handle, which ends abruptly one-half inch above a horizontal bar. Apparently, a pottery mug, similar to one in the British Museum made by John Dwight of Fulham, [25] served as the model. The handle of the Dwight piece was so firmly pressed to the body that it appears to be separate from its short, rolled end, and the Chinese workman interpreted it as two pieces.

Only a minority of export porcelains were special orders. In some cases, notably vessels associated with tea drinking, Chinese forms were accepted by the Westerner and adapted to his own customs and habits. Chinese teabowls, teapots, and tea caddies (Figures 11 and 75) remained popular, though Europeans devised their own versions (Figure 55). Although the shape of the cup in Figure 9 is Chinese, the polychrome inner border suggests that it was intended for export, probably to the Continent. The cup was used for ceremonial offerings in China, but its European function is unknown. A similar cup in the Toledo Museum of Art has an oval stand with matching border. Besides utilitarian forms, Westerners eagerly collected porcelain pagodas and oriental figures to ornament the cupboards and mantles of their homes.

As the China trade expanded in the eighteenth century, the forms of porcelain multiplied in response to the varied national demands. Once added to the potter's repertoire, a form could be purchased by any nation, regardless of the original model. Thus a fruit basket, derived from mid-eighteenth-century Meissen designs, was probably made initially for a German customer. Winterthur's example, however, bears the badge of the Order of the

Cincinnati, the society of Revolutionary War officers, and belonged to Samuel Shaw, America's first supercargo at Canton (Figure 22). [26]

Painted Designs for the West

In spite of Western demands for special forms and K'ang-hsi's personal interest in "new and curious designs," many China trade porcelains before 1740 are painted with Chinese subjects (Plate 1; Figure 14). Oriental flowers, figures, and landscapes, sometimes presented in a non-Chinese manner, occur on export wares throughout the reign of Ch'ien Lung (Plate 3; Figure 34). After 1800, there was considerable Western interest in new Chinese-inspired patterns that were busy and colorful (Figures 37 and 38).

It is only in the porcelains designed for the West in both form and decoration that the nature of the export trade can be fully understood. Pictorial subjects ran the gamut from biblical scenes (Figure 40) to medical illustrations (Figure 52). Early renditions of European figures reveal how strange the foreigners appeared to oriental eyes, although realistic figure drawing was something Chinese painters never fully mastered (Plate 7). Portraits are rare (Figures 44, and 46−48), and they were often politically motivated (Figures 49−51). Western literature (Figure 57) and mythology (Figures 42 and 43) also provided ideas for figural decoration. Genre scenes, copied from popular engravings, feature children and adults at play (Plates 9 and 13; Figures 55 and 64). The first recognizable European landscape scene on Chinese porcelain commemorates the Rotterdam riots of 1690. After 1750, specific buildings (Figure 59) and towns as well as generalized European harbor views were regularly painted at Canton (Figure 58). Toward the end of the century, much export ware had small, monochromatic views, probably copied from book illustrations (Figures 62, 63, and 88a). Export porcelains exhibit an endless variety of border patterns, from the simple to the complex. Along

with other pictorial motifs, these patterns were introduced into the Chinese painters' vocabulary by way of drawings, prints, ceramics, and other arts. Decorative motifs of oriental style were derived from novels, antique porcelains, and other arts, as well as from nature. [27]

The Chinese developed assembly-line techniques to ensure uniformity. According to d'Entrecolles, the underglaze painting at Ching-te Chen

> is distributed in the same workshop among a great number of workmen. One workman does nothing but draw the first colour line beneath the rims of the pieces; another traces flowers, which a third one paints; this man is painting water and mountains, and that one either birds or other animals.

The system did nothing to help the Chinese painters understand European representational art, yet objects with well-integrated scenes are surprisingly common, and, considering that the huge workshops in Canton operated in the same fashion as those at the potteries, rather remarkable. [28]

Personalized Porcelains

The ultimate special-order porcelains were those designed to individual taste. Not surprisingly, some of the most interesting and successful decorations were made for the officials of the East India companies and for the ship captains, supercargoes, and others involved directly in the trade.

Personal coats of arms, in use from the Middle Ages, appear on seventeenth-century European pottery but were not common on China trade wares until the eighteenth century. Heraldic bearings ranged from the full achievement of shield, helmet, wreath, crest, and motto to crests alone (Plate 10; Figure 67). An unusually elaborate armorial service was made for Theodorus van Reverhorst (Figure 66). Each piece displays not only his arms, but those of each of his eight great-grandparents.

Persons not entitled to bear arms often devised their own and

had them emblazoned on porcelain. Full names are rarely written out but surnames are not unknown (Figures 73a, 77, and 78). Initials of either given names or surnames are sometimes displayed in mantling, and sets of initials are occasionally joined to commemorate a marriage (Figures 73b and 74).

Heraldic bearings of nations, cities, and private societies also occur on export ware. Among the important armorial porcelains of the K'ang-hsi period are sets of large dishes painted with the arms of the chief towns and provinces of the United Netherlands. [29] Trade guilds are known to have ordered china with their arms. The garniture displaying the arms of the London Watermen's Company was probably donated by the owner of the initials "TLB" (Figure 81). English pottery bearing the arms of Liverpool's fashionable Society of Bucks is not uncommon, but Chinese examples are rare (Figure 80). [30] Freemasonry was a widespread phenomenon of eighteenth-century Europe and America, and it is hardly surprising to find Chinese porcelains painted with the symbols of the brotherhood (Figure 79).

True armorial porcelain formed a mere fraction of the total number of porcelains exported to the West. It has been estimated that the four thousand or so armorial services destined for England represent less than one percent of the porcelains sent to that country. Even so, one service with arms, comprising an average of three hundred pieces and costing ten times as much as nonarmorial porcelain, must have been completed every nine days of the eighteenth century. [31] This does not include the armorial services made for the Portuguese, French, Dutch, Swedish, and other European markets. Only a few examples of armorial porcelain are known to have been made for the American market, and the handful that do survive reveal an even more casual attitude toward heraldry than was prevalent in England. [32]

The usual models for armorial designs sent to China were engraved bookplates and drawings. Arms copied from the former are more linear and precise than those taken from the latter. Sometimes, arms are shown facing the wrong way, the result of using the matrix of a seal rather than its impression.

The American Trade

The first Chinese porcelains to reach the American continent came to the west coast in the sixteenth century on Spanish ships from the Philippines. [33] Both Chinese and Japanese export wares were enjoyed by the Dutch of New Netherlands in the seventeenth century. The colonists of the English settlements used Chinese porcelains, though not in any quantity until the second quarter of the eighteenth century, when "chinaware" occurs with some frequency in newspaper advertisements and household inventories.

In February, 1784, a year after the signing of the peace treaty that ended the Revolutionary War, the first American ship, *Empress of China*, left New York for Canton. Samuel Shaw (Figures 22 and 90), supercargo, recorded its arrival.

> Ours being the first American ship that had ever visited China, it was some time before the Chinese could fully comprehend the distinction between Englishmen and us. They styled us the *New People*, and when, by the map, we conveyed to them an idea of the extent of our country . . . they were not a little pleased at the prospect of so considerable a market . . . [34]

American merchants were similarly pleased with the commercial potential. By 1790, the "New People" had sent twenty-eight ships to Canton. No American East India Company existed; instead, the trade was entirely the result of individual enterprise. The cargo of the sloop *Experiment*, sent to China in 1785, was typical of the early period of trade: tar, turpentine, rosin, varnish, tobacco, snuff, ginseng, furs (mink, red fox, gray fox, wild cat, marten, bear, raccoon, muskrat, spotted fawn), and some specie. [35] The Americans received in exchange the usual assortment of teas, textiles, and chinaware.

The trade with China peaked in the early years of the nineteenth century and began to decline after 1830. The treaty of Wanghia in 1844 (Figure 96) extended the trading terms between the United States and China and business continued until the Civil War. The nature of the trade had changed, however, and as one American noted in 1845, "The same articles which we

formerly imported from China, and for which nothing but dollars would pay, are now manufactured here at one third the cost, and sent out to pay for teas." [36] Thus the economic base of American–Chinese trade had decayed, and the British potting industry had effectively taken over the American market for ceramics.

The people who were directly involved in the China trade owned some of the most interesting porcelains. Elias Hasket Derby, one of the great merchants in the China trade, ordered a set with the crestlike motif of "Hope" (Figure 82). Henry Smith, supercargo of the *George Washington*, owned a spectacular punch bowl (Plate 14). Samuel Shaw's porcelain (Figures 22 and 90) was only one of several sets painted with the badge of the Order of the Cincinnati. The most famous of these was owned by George Washington (Figure 89). America's first president was occasionally the subject of Chinese export porcelains. His portrait on a jug (Figure 87) is a splendid example of Chinese copy work. A similarly accurate portrait of Captain Stephen Decatur, Sr., decorates another jug (Plate 16).

State seals are rarely depicted correctly on Chinese porcelain (Plate 15). Adaptations, especially of the arms of New York State, were popular—and not only in America. Porcelains with variations of the New York arms have been found, for example, in Portugal. [37] Similarly, the national seal appears in its official version only occasionally, but eagles, in many shapes and forms (Figures 91–96), became popular emblems for fancier American-market wares. Ships involved in the China trade were themselves favorite pictorial themes. During the American period, interest in marine subjects ran high, perhaps because shipping was so important to the economy of the new republic (Figure 97). All of these polychrome special-order pieces, however, represent but a fraction of the millions of porcelains exported to America. The majority were the crudely painted blue and white porcelains that came to be known as Canton and Nanking wares.

Notes

1. Jean Baptiste du Halde, *Description geographique, historique . . . de l'empire de la Chine (1736)*, quoted in B. Sprague Allen, *Tides in English Taste (1619 – 1800)*, vol. I (New York: Rowman and Littlefield, 1969), p. 183.

2. Loys Guyon, quoted in John Goldsmith Phillips, *China-Trade Porcelain* (Cambridge, Mass.: Harvard University Press, 1956), p. 42.

3. *A Tour thro' Whole Island of Great Britain* (1724), intro. G. D. H. Cole, vol. I (London: Peter Davies, 1927), p. 166.

4. *Mercurius Politicus*, London, Sept. 23 – 30, 1658, quoted in Rodris Roth, "Tea Drinking in 18th-Century America: Its Etiquette and Equipage," *United States National Museum Bulletin*, no. 225 (1961), p. 64.

5. *An Estimate of the Manners and Principles of the Times*, 2d ed. (London: L. Davis, 1757), p. 48.

6. Clare Le Corbeiller, *China Trade Porcelain: Patterns of Exchange* (New York: Metropolitan Museum of Art, 1974), pp. 12 – 16.

7. Supercargo of *Confederacy*, Sea Journal 1804, Ms. 74 x 96, Joseph Downs Manuscript and Microfilm Collection, Winterthur Museum Libraries (hereafter DMMC). A ship of that name was built in 1794 and registered in New York in 1795.

8. David Sanctuary Howard, *Chinese Armorial Porcelain* (London: Faber and Faber, 1974), p. 31.

9. *Confederacy* Sea Journal, DMMC.

10. Marco Polo, *The Travels of Marco Polo*, rev. and ed. Manuel Komroff (New York: The Modern Library, 1953), pp. 251 – 52.

11. Francis Bacon, *The Works of Francis Bacon*, coll. and ed. James Spedding, Robert Leslie Ellis, and Douglas Devon Heath, vol. XV (Boston: Brown and Taggard, 1861), p. 37.

12. Walter A. Staehelin, *The Book of Porcelain*, trans. Michael Bullock (London: Lund Humphries, 1966), p. 22.

13. Letter of d'Entrecolles, Sept. 1, 1712, quoted in William Burton, *Porcelain: Its Nature, Art and Manufacture* (London: B. T. Batsford, 1906), p. 91.

14. The terms *famille verte* and *famille rose* were popularized by Albert Jacquemart and Edmund Le Blant in their *Histoire artistique industrielle et commerciale de la Porcelaine* (Paris: J. Techener, 1862).

15. Clare Le Corbeiller, *China Trade Porcelain: A Study in Double Reflections*, exhibition Oct. 25, 1973 – Jan. 27, 1974, China House Gallery (New York: China Institute in America, 1973), p. 10.

16. Le Corbeiller, *Patterns*, p. 7.

17. Howard, p. 43.

18. For example, the set made for Deborah Fairfax Anderson of Salem brought to her on board the *Grand Turk* in 1786. Homer Eaton Keyes, "The Chinese Lowestoft of Early American Commerce," *Antiques*, vol. 16 (Nov., 1929), p. 382.

19. Philadelphia County Probate Records (1759), microfilm 1026, no. 221, DMMC.

20. D. F. Lunsingh Scheurleer, *Chinese Export Porcelain: Chine de Commande* (New York: Pitman, 1974), pp. 178 – 86, pls. 350 – 53; W. B. Honey, "Dutch Decorators of Chinese Porcelain," *Antiques*, vol. 21 (Feb., 1932), pp. 75 – 80; W. W. Winkworth, "The Delft Enamellers," *Burlington Magazine*, vol. 52 no. 303 (June, 1928), pp. 296 – 302.

21. Scheurleer, pp. 55 – 56.

22. Scheurleer, p. 56.

23. D'Entrecolles, in Soame Jenyns, *Later Chinese Porcelain: The Ch'ing Dynasty (1644 – 1912)*, 4th ed. (London: Faber & Faber, 1971), p. 9.

24. Lan P'u, *Ching-te Chen, T'ao Lu or The Potteries of China*, trans. and intro. Geoffrey R. Sayer (London: Routledge & Kegan Paul, 1951), p. 17.

25. Le Corbeiller, *Patterns*, p. 23.

26. On his first visit to Canton, Shaw wanted a china painter to combine several Cincinnati motifs on unspecified ceramic forms, but he was only able to copy a single design "with the greatest exactness." Samuel Shaw, *The Journals of Major Samuel Shaw with a life of the author*, by Josiah Quincy (Boston: Wm. Crosby and H. P. Nichols, 1847), pp. 198 – 99.

27. T'ang Ying, director of the imperial porcelain factory, described porcelain decoration around 1743. Jenyns, p. 7.

28. Descriptions of the Canton workshops are quoted in Jean McClure Mudge, *Chinese Export Porcelain for the American Trade 1785 – 1835* (Newark: University of Delaware Press, 1962), pp. 52 – 53, 74 – 76.

29. Le Corbeiller, *Patterns*, pp. 38 – 39.

30. Howard, pp. 273, 452.

31. Howard, pp. 67 – 68.

32. Howard, p. 82.

33. Carl Robert Quellmatz, "Chinese Porcelain excavated from North American Pacific Coast Sites," *Oriental Art*, vol. 18 no. 2 (Summer, 1972), pp. 148 – 54.

34. Shaw, p. 183.

35. Frances Little, "America's East Indiamen and the China Trade," *Antiques*, vol. 15 (Jan. 1929), p. 31.

36. Philip Hone, quoted in Mudge, p. 124.

37. J. A. Lloyd Hyde, *Oriental Lowestoft*, 3d ed. (Newport, England: Ceramic Book Company, 1964), p. 156.

Selected Bibliography

Beurdeley, Michael. *Porcelain of the East India Companies.* London: Barrie and Rockliff, 1962.

Bluett, Edgar E. *Ming and Ch'ing Porcelains.* London: Chiswick Press, 1933.

The China Trade and Its Influences. New York: Metropolitan Museum of Art, 1941.

Chinese Export Porcelain and Enamels. (Catalog of an exhibit, September 25 – October 27, 1957.) Wilmington, Delaware: Wilmington Society of the Fine Arts, 1957.

Crossman, Carl L. *A Design Catalog of Chinese Export Porcelain for the American Market 1785 to 1840.* Salem, Massachusetts: Peabody Museum, 1964.

An Exhibition of China Trade Porcelain. New Haven, Connecticut: New Haven Colony Historical Society, 1968.

Hobson, R. L. *The Later Ceramic Wares of China.* New York: Charles Scribner's Sons, 1925.

Howard, David Sanctuary. *Chinese Armorial Porcelain.* London: Faber & Faber, 1974.

Jenyns, Soame. *Later Chinese Porcelain: The Ch'ing Dynasty (1644 – 1912).* 4th ed. London: Faber & Faber, 1971.

Le Corbeiller, Clare. *China Trade Porcelain: A Study in Double Reflections.* New York: China Institute in America, 1974.

———. *China Trade Porcelain: Patterns of Exchange.* Additions to the Helena Woolworth McCann Collection in the Metropolitan Museum of Art. New York: Metropolitan Museum of Art, 1974.

Lloyd Hyde, J. A. *Oriental Lowestoft.* 3d ed., Newport, England: Ceramic Book Company, 1964.

Mudge, Jean McClure. *Chinese Export Porcelain for the American Trade 1785 – 1835.* Newark, Delaware: University of Delaware Press, 1962.

Phillips, John Goldsmith. *China-Trade Porcelain.* Cambridge, Massachusetts: Harvard University Press, 1956.

The Reeves Collection of Chinese Export Porcelain. Lexington, Virginia: Washington and Lee University, 1973.

Roth, Stig. *Chinese Porcelain Imported by the Swedish East India Company.* Translation, Mary G. Clarke. Gothenburg, Sweden: Gothenburg Historical Museum, 1965.

Scheurleer, D. F. Lunsingh. *Chinese Export Porcelain: Chine de Commande.* London: Faber & Faber, 1974.

Staehelin, Walter A. *The Book of Porcelain.* Translation from German by Michael Bullock. London: Lund Humphries, 1966.

Williamson, George C. *The Book of Famille Rose.* 1927. Reprint. Rutland, Vermont: Chas. E. Tuttle, 1970.

Illustrations

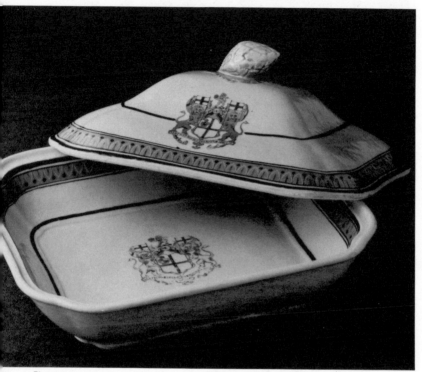

Figure 1

Figure 1. *Covered Dish. Ca. 1805.
Painted with the arms of the Honourable
East India Company of Great Britain,
this service was used by company
officials stationed in the East. Its
distinctive brown and orange leaf border
was inspired by the earthenware of Josiah
Wedgwood. OH: 6¼″ (15.9 cm), OW: 11¼″
(28.6 cm); acc. no. 56.46.114.*

Figure 2

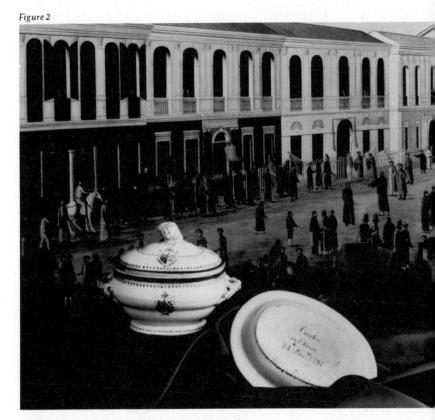

Figure 2. *Sauce Tureen and Stand. Dated 1791. Shown against an early 19th-century view of the Hongs in Canton is a sauce tureen from a unique English-market service. Each piece bears the painted inscription: "Canton/in China/24th Jan.ʸ 1791." The tureen has the polychrome arms of Chadwick quartering the coats of Malvesyn, Carden, and Bagot; other pieces made for the Chadwick family have arms with six quarters. OH (tureen): 5¼" (13.35 cm), OW (stand): 7¾" (19.7 cm); acc. no. 63.780.1.*

Figure 3

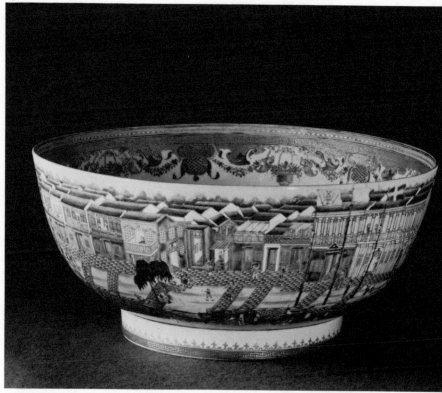

Figure 3. *Bowl. Ca. 1780. This brightly colored Hong bowl features the trading offices, or Hongs, along the river in Canton where all the business of the export trade was conducted. OH: 6⅛″ (15.6 cm), Diam: 13⅞″ – 14⅛″ (35.3 – 35.9 cm); acc. no. 60.572.*

Figure 4

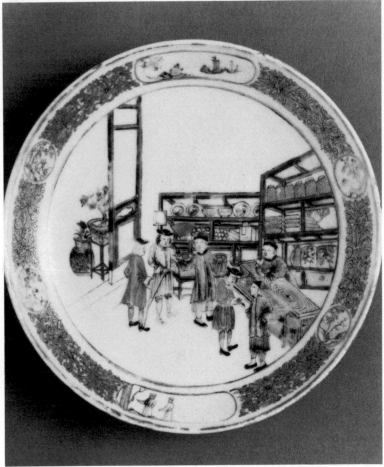

Figure 4. *Saucer. 1730–40. The saucer depicts European merchants bargaining in a Canton shop. Porcelains are among the goods shown on the shelves. Diam: 5⅛″ (13.05 cm); acc. no. 66.588.* **Plate 1.** *Water Cistern and Basin. 1700–30. Such sets for the rinsing of hands were necessary features in many dining rooms of the late 17th and early 18th centuries. This famille verte example derives its shape from Continental faience, but its central design is purely Chinese. OH (cistern): 17⅞″ (45.4 cm); acc. no. 66.768, .769.*

Plate 1

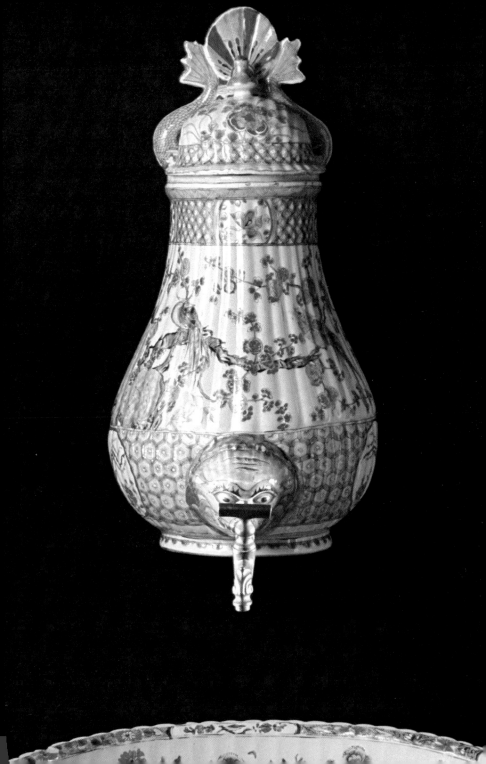

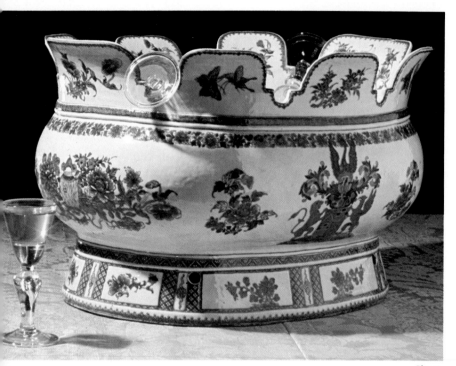

Plate 2

Plate 2. *Monteith. 1720–30. Monteiths were an
English invention of the 1680s designed to hold ice
water in which to rinse and chill wineglasses and
decanters. The arms are probably of a Continental
family. OW: 20⅛″ (51.15 cm); acc. no. 60.763.*

Plate 3. *Tureen and Stand. 1765 – 75. This service illustrates the soft "foreign" colors that came to dominate Ch'ien Lung production. Originally owned by Alexander Henderson (1738 – 1815) of Dumfries, Va., these porcelains are among the few that can be documented to colonial America. OH: 8¼" (20.95 cm); gift of Mrs. Cazenove Lee; acc. no. 68.286.1.*

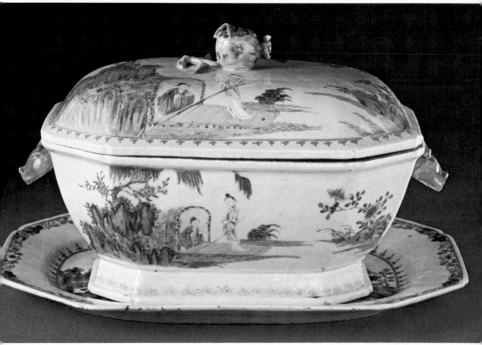

Plate 3

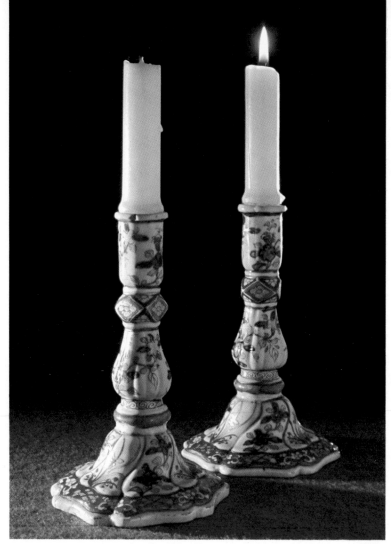

Plate 4

Plate 4. *Candlesticks. 1745–60. In form, these candlesticks reflect the rococo movement of European art, but their floral decoration is oriental. Japanese porcelains made at the Arita kilns were painted in underglaze blue, red enamel, and gilt and were shipped from the port of Imari to Europe. The so-called Imari style was copied by the Chinese and became a popular model for western potteries. OH: 6½″ (16.5 cm); acc. nos. 59.1351,.1351.*

Figure 5. *"Sample" Plate and Covered Custard Cup. 1790–1810. From such multiborder pieces, a Westerner could select the style he wished to have his "chinaman" order. The custard cup, bearing the initials "AT," and the plate with its pseudoarmorial "P," illustrate the standardization and simplicity of designs that marked the turn of the 18th century. OH (cup): 3⁵⁄₁₆" (8.7 cm), Diam (plate): 9⅞" (25.1 cm); acc. no. 66.589; gift of Mr. and Mrs. John Mayer, acc. no. 73.241.*

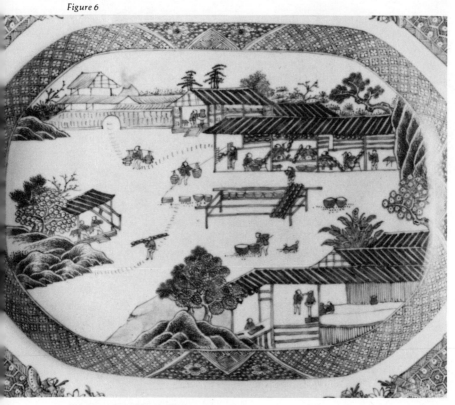

Figure 6. *Detail, Deep Dish. 1770–85.*
The dish, painted in underglaze blue,
shows the potters of Ching-te Chen at
work. In the background a potter stands
at his wheel, while decorators embellish
the greenware and set it out to dry in
the sun. Finished pieces are carried
to the kilns to be fired. OW (dish):
14¹³⁄₁₆″ (37.7 cm); acc. no. 67.1495.

Figure 7

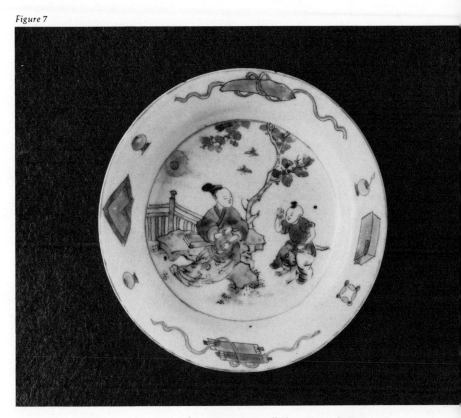

Figure 7. *Small Plate. K'ang-hsi. A Chinese scene is painted in* famille verte *translucent enamels on this very white, . delicate plate. Around the rim are several of the "Eight Precious Things" of Chinese iconography. Diam: 4½″ (11.45 cm); acc. no. 58.1484.*

Figure 8

Figure 8. *Barber Basin. 1735–45. Barber basins were among the earliest forms ordered for Western markets. This example, in the* famille rose *palette, exemplifies the Chinese-style designs of the beginning of the reign of Ch'ien Lung. OW: 13¹⁄₁₆″ (33.2 cm); acc. no. 58.2365.* **Figure 9.** *Cup. 1750–70. Although this cup is a traditional Chinese form, the polychrome enameled inner border suggests that it was intended for export. Delicate floral and fruit sprays were shaped by hand and then applied to the exterior surface. Originally, there was probably an accompanying stand. OH: 3″ (7.65 cm); acc. no. 58.3067.*

Figure 9

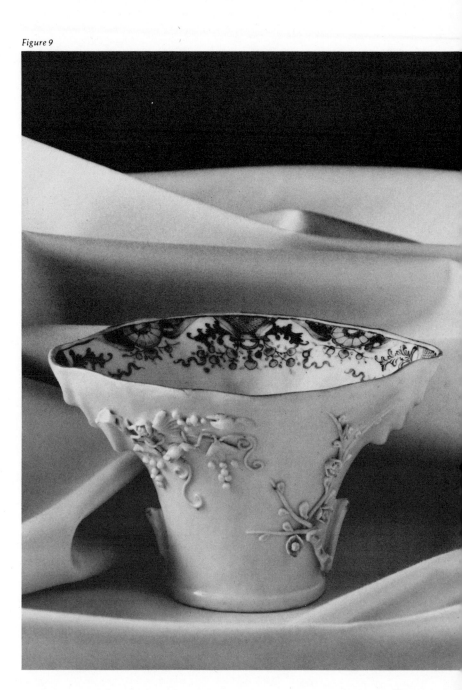

Figure 10

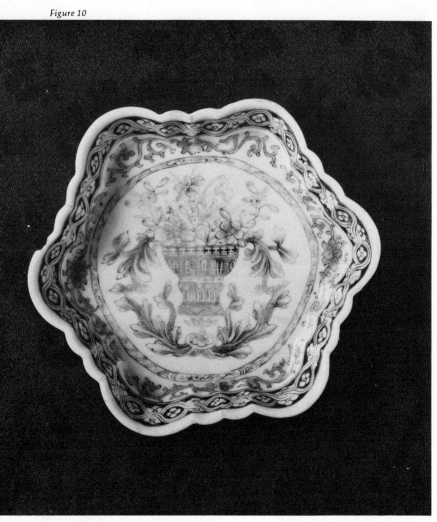

Figure 10. *Teapot Stand. 1740—50.
This teapot stand is delicately painted
in* encre de chine *and highlighted with
gilt. OW: 4¾″ (12.1 cm); acc. no.
65.606.*

Figure 11

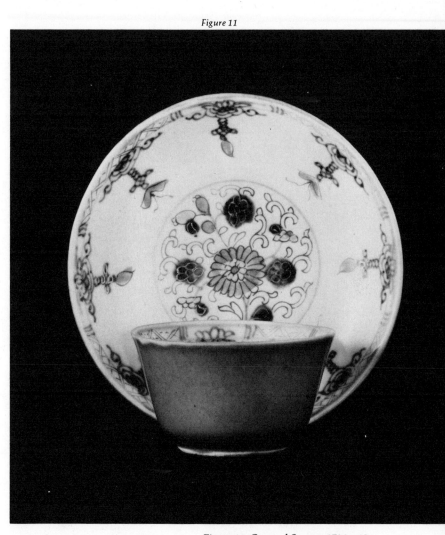

Figure 11. *Cup and Saucer. 1720–40. The exterior of each piece is coated with a brown glaze, and the interiors feature colorful floral motifs in the "Imari" taste. OH (cup): 1⁹⁄₁₆" (4 cm), Diam (saucer): 4¹¹⁄₁₆" (11.9 cm); acc. no. 75.99.*

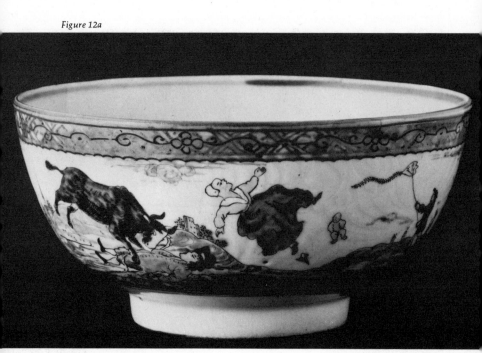

Figure 13

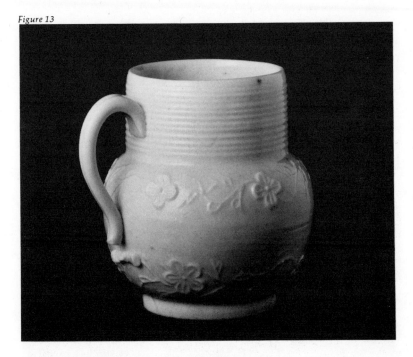

Figure 12a. *Bowl. Body: 1715—25. Enamel Decoration:
1740—50. The carved design of the bowl's exterior,
as well as its underglaze blue borders and inner motif*
(Figure 12b), *are only partially obscured by a Dutch
enameler's work. The bizarre scene, supposed to have
occurred on the date painted on the bottom of the bowl*
(Figure 12c), *shows a woman who gave birth when she
was knocked into the air by the bull that is goring
her husband. The same "Wonder at Zaandam" motif
appears on Chinese-decorated porcelains. OH:
2¹³/₁₆" (7.2 cm), Diam: 5¹⁵/₁₆" (15.1 cm); gift
of Charles K. Davis; acc. no. 56.46.55.* **Figure 13.**
*Mug. 1690—1700. Te-hua Ware. Small mugs of this
shape were made in Europe from the late 17th century
through the 18th century. A pottery example was
apparently the model for this Chinese version with
its misunderstood handle terminal, but the plum
blossoms are purely Chinese in taste. The potteries
near Te-hua in Fukien Province, enjoying direct trade
with Europeans between 1650 and 1750, were famous for
their blanc de chine porcelains: "white like snow
without sheen." OH: 3⅝" (9.2 cm);* ex coll.
Gordon A. Rust; acc. no. 75. 114.

Figure 14. *Candlestick. 1700–20. A K'ang-hsi blue
and white candlestick echoes the spiral twists found
on Western furniture and metalwares of the period. OH:
6" (15.25 cm); acc. no. 58.3098.* **Figure 15a.** *Cane Handle.
1720–30. A ceramic example was probably the model
for this molded piece decorated in rouge de fer. OL:
5¼" (13.35 cm); acc. no. 66.619.* **Figure 15b.** *Tile.
Ch'ien Lung. This porcelain tile, painted in shades
of purple, confirms written evidence of Dutch delftware
tiles being sent to China to be copied. The Chinese
versions were probably sent to the East Indies. Tiles
were used in walls or fireplace surrounds, or as stands
for teapots and hot dishes. 5" square (12.7 cm); gift
of Mr. and Mrs. John Mayer; acc. no. 70.425.*

Figure 14

Figure 15a

Figure 15b

Figure 16

Figure 16. *Porringer. 1700—30. A metal or earthenware porringer must have been the model for this unusual piece. Decorated in underglaze blue, it features a triangular handle with a pierced quatrefoil. Several* famille rose *porringers of this form are known. OH: 2³/₁₆″ (5.6 cm), OW: 6⅛″ (15.6 cm); acc. no. 61.64.*
Figure 17. *Inkstand. Ca. 1720. This early blue and white inkstand demonstrates the great variety of forms the Europeans demanded of the craftsmen at Ching-te Chen. While the Chinese had always made porcelain accessories for the writing table, the Western scholar's needs were unlike those of his Eastern counterpart. OH: 3″ (7.65 cm), OW: 8″ (20.3 cm); acc. no. 58.1529.*

Figure 17

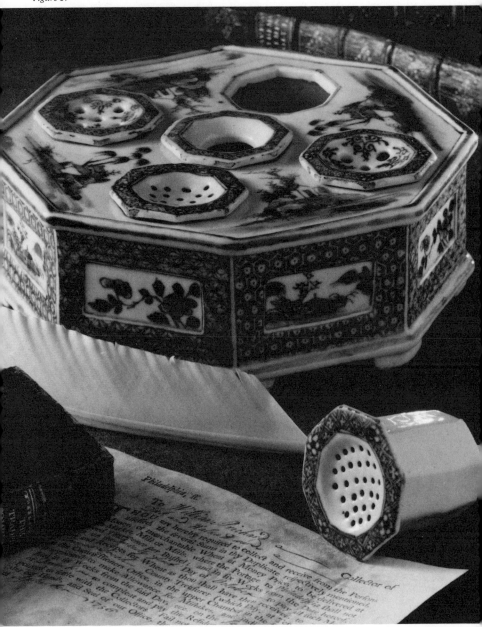

Figure 18

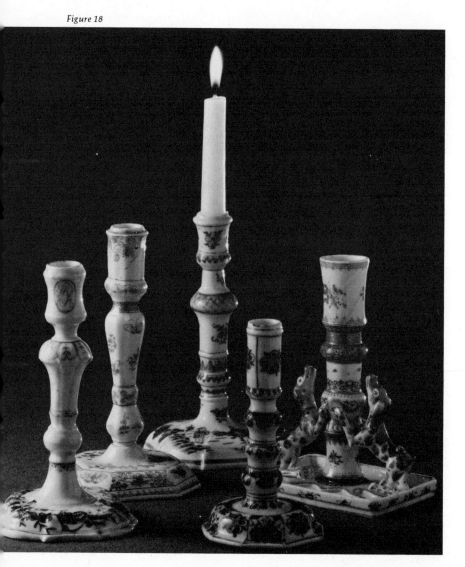

Figure 18. *Candlesticks. 1700−1800. Chinese porcelain candlesticks were made in as many shapes as their European prototypes. This group summarizes the decorating techniques of the 18th century, from rich underglaze blue (3rd and 4th from left) to* rouge de fer *and gold (2nd from left), and from* encre de chine *(left) to brilliant polychrome enamels (right). OH (tallest): 7½″ (19.1 cm); acc. nos. (from left to right) 61.891; 60.1164.1; 58.744; 56.38.73; 59.2861.*

Figure 19

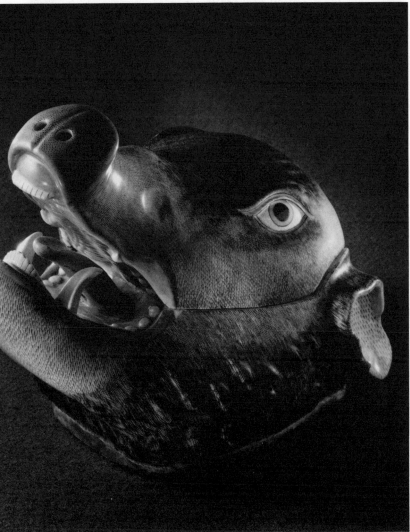

Figure 19. *Tureen. Ch'ien Lung. Tours de force such as this were favorite table items in the days when dining was as much an entertainment as a necessity. This boar's head must have been quite fearsome when steam from hot soup poured out of its nostrils. OH: 11⅝″ (29.55 cm), OL: 13⅞″ (35.3 cm); acc. no. 66.611.*

Figure 20

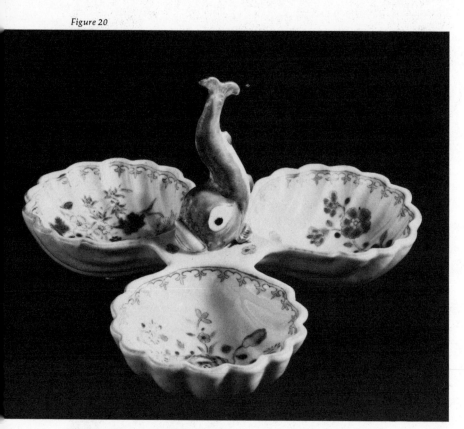

Figure 20. *Sweetmeat Dish. Ca. 1750.
The shell-shaped cups of this rococo
serving piece are decorated in opaque
famille rose colors and the dolphin
handle is a bright orange. OH: 4⅞″
(12.4 cm); acc. no. 58.2697.*

Figure 21

Figure 21. *Salt Dishes. 1740–1800.*
Painted in famille rose *colors, these*
pieces demonstrate the change from
Chinese-style flowers to those of
European inspiration. The forms were
derived from silver. OH (tallest): 2˝
(5.1 cm); acc. nos. 58.2693; 58.2691;
58.2661.

Figure 22

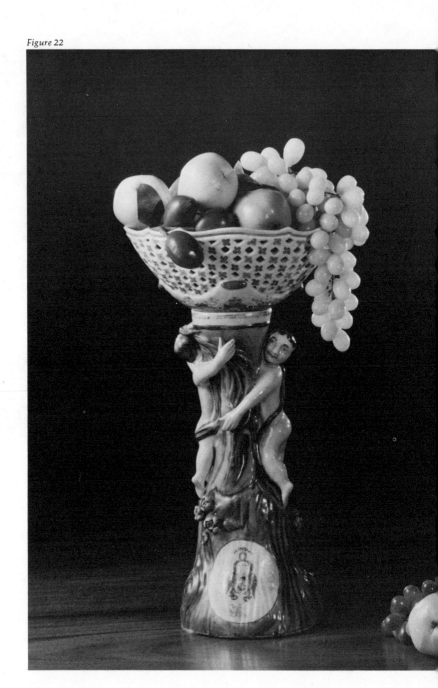

Figure 23

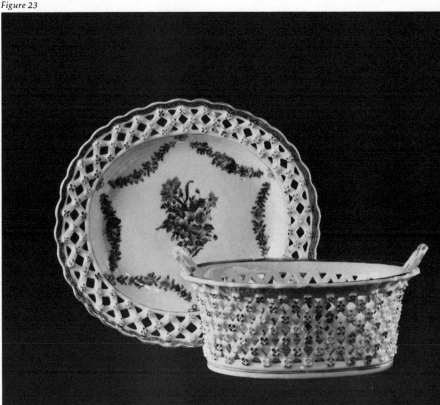

Figure 22. *Fruit Basket on Stand. 1785–90. The Meissen factory made compotes of this style in the mid-18th century. The stand, painted to resemble a tree trunk, features the badge of the Society of the Cincinnati that Samuel Shaw had painted on other porcelains he bought while in Canton. OH: 14⅞″ (37.9 cm); ex coll. Mrs. Francis Shaw; acc. no. 59.2934.* **Figure 23.** *Basket and Tray. 1765–80. This pierced fruit basket with molded rosettes parallels those made at English porcelain factories in the second half of the 18th century. Its floral swags are predominantly pink. OH (basket): 3¹³/₁₆″ (9.7 cm), OW (tray): 9¼″ (23.5 cm); acc. no. 66.580.1.*

Figure 24

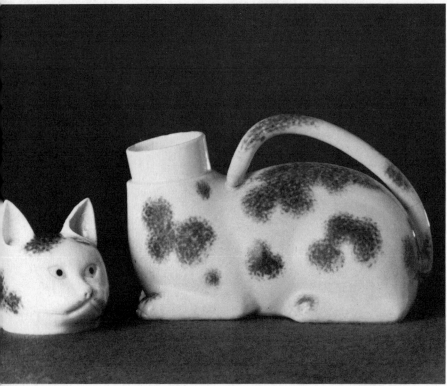

Figure 24. *Urinal. 1830–50. Functional cats were made in the K'ang-hsi period, though the ones that d'Entrecolles describes were night lamps made to keep rats away. This discreet bedroom accessory, with its tail-handle, has underglazed blue sponged decoration. It was originally owned by Dr. Thomas Rodney Brinckle (1804–53) of Philadelphia. OH (with head): 7¾" (19.7 cm); gift of Miss Gertrude Brinckle and Miss Gertrude Rodney; acc. no. 64.147.* **Figure 25.** *Tureen. Ch'ien Lung. This well-modeled and realistically painted tureen in the form of a goose supports d'Entrecolles's high opinion of the Chinese-made porcelain animals. OH: 13⅛" (33.35 cm); acc. no. 61.870.*

Figure 25

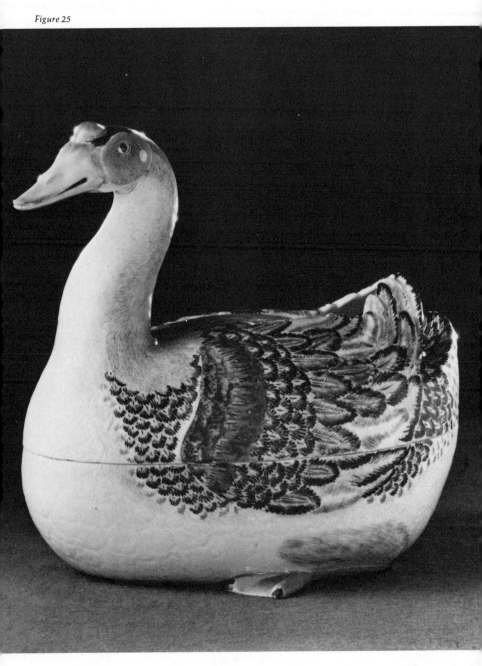

Figure 26

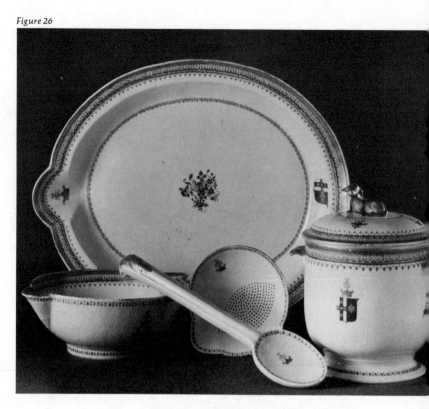

Figure 26. *Milk Platter, Bowl, Strainer, Spoon, and Cooler. 1792–1800. This 17-piece dairy set is extremely rare if not unique in China trade porcelain. Painted with the arms of Neave impaling Digby, it was owned by Sir Thomas Neave (b. 1761) of Essex, England, who married Frances Caroline Digby in June, 1791. Neave's father, Sir Richard (d. 1814) was involved in the China trade and was, therefore, probably responsible for ordering the service. OL (spoon): 15" (38.15 cm); acc. nos. 66.569.2,.3,.8,.13,.17.* **Figure 27.** *Tureen. Ch'ien Lung. The water buffalo, native to China, was employed to knead the clay during the refining process of porcelain clay. The adaptation of the animal to a soup tureen was a European innovation. Other examples are known with matching stands. OH: 15" (38.15 cm); acc. no. 66.568.*

Figure 27

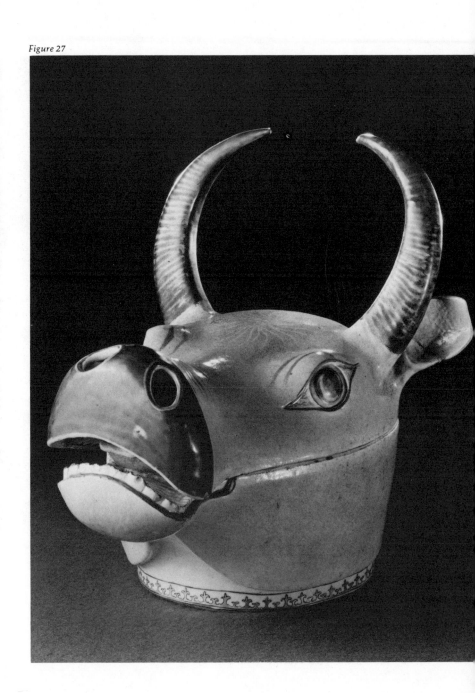

Figure 28

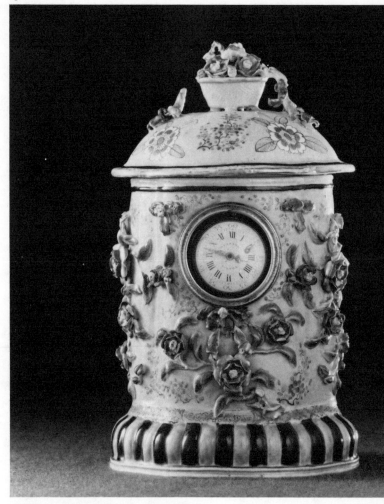

Figure 28. *Watch Holder. 1750 – 75. This is one of the gaudier porcelains Europe demanded of China. The body has an apple-green ground; polychrome modeled flowers were applied to the front and lid and orange flowers were painted on the the rear and lid. The gadrooned base is striped in black and aqua. The prototype for the form is unknown. OH: 8″ (20.3 cm); acc. no. 58.1815.*

Figure 29

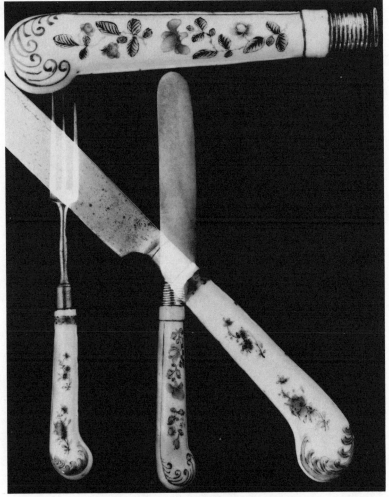

Figure 29. *Handles of Knives and Forks. Ch'ien Lung. Ceramic handles for eating utensils were among the eccentric forms sought by the "foreign devils." These examples are decorated in polychrome enamels. OL: 8¾" (22.25 cm); acc. nos. 66.634.4,.5;66.608.5,.10.*

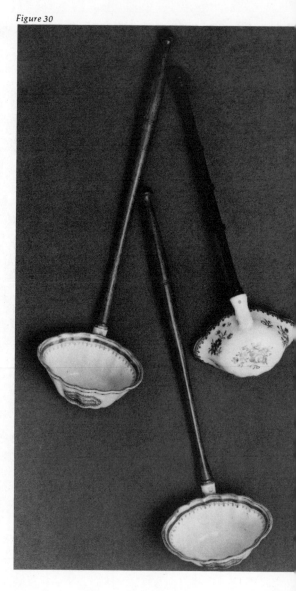

Figure 30

Figure 30. *Ladles.
1760 – 1810. Ladle bowls,
copied from silver, were
made in China from about
1760. The pair on the
left dates from the early
19th century and features
a Western landscape scene
in sepia and the initials
"JL." OW (bowls): 3¾"
(9.55 cm); acc. nos.
59.1343; 61.672.1,.2.*
Figure 31. *Covered Urn.
1775 – 1800. The original
model for ornamental urns
of this shape was designed
at the Marieberg pottery
in Sweden during the 1770s.
This large and carefully
painted example is one of
a pair. OH: 26" (66.1 cm);
acc. no. 61.692.1.*

Figure 31

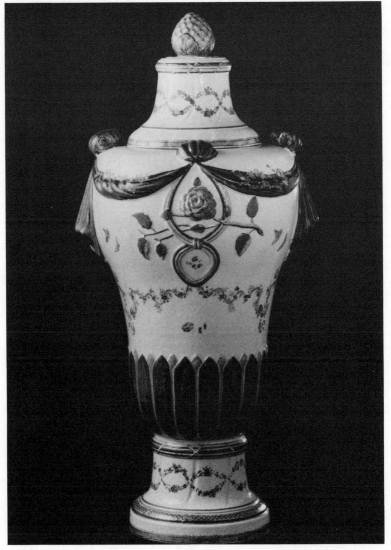

Figure 32

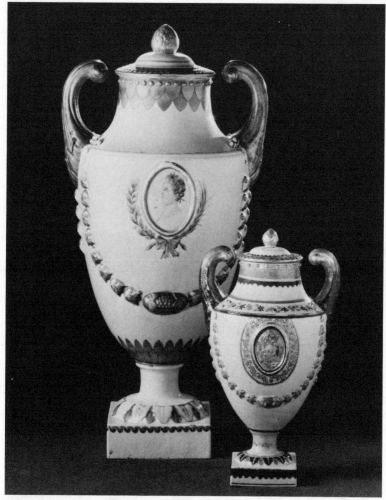

Figure 32. *Covered Urns. 1785–1815. Pistol-handled urns were popular ornaments in the homes of wealthy Americans. The exceptionally large orange and gilt urn with the classical bust is one of a pair that may have belonged to Joseph Bonaparte when he lived near Bordentown, N.J. The medallion of the smaller urn has a beautifully painted scene in polychrome on a gilt ground. OH (tallest): 26½″ (67.4 cm); ex coll. Mrs. Francis B. Crowninshield; gift of Franklin B. Benkard, acc. no. 58.137.1; acc. no. 61.1451.1.*

Figure 33

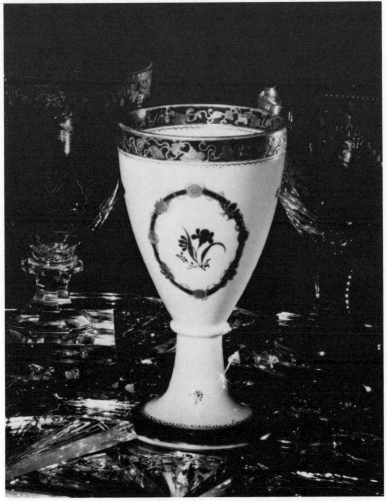

Figure 33. *Goblet. 1790–1800. Because glass was the preferred material for drinking vessels, this porcelain goblet is especially rare. The grapevine border and other motifs are richly rendered in gilt and blue enamel. OH: 5¼″ (13.35 cm); acc. no. 65.555.*

Figure 34

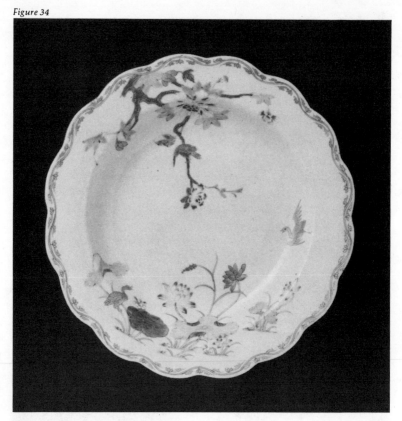

Figure 34. *Soup Dish. 1745–60. The asymmetrical design on this dish is unusual in Chinese export ware. The decoration is delicately painted in pastel opaque colors and shows the importance of white enamel in the early Ch'ien Lung porcelain. Diam: 9" (22.9 cm); acc. no. 69.1683.2.*

Figure 35

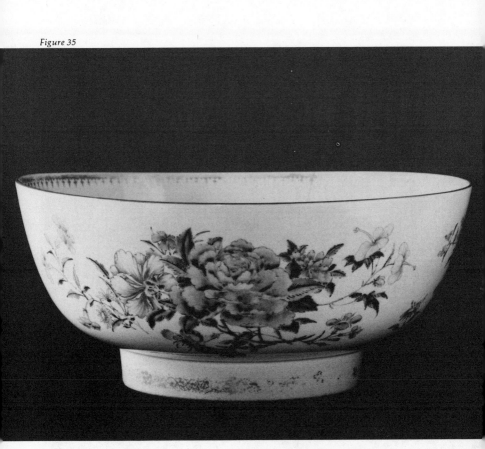

Figure 35. *Bowl. 1755—75. The Chinese love of nature is suggested by the flowers, of a superb quality* famille rose, *that surround this bowl. A portrait medallion ornaments the center bottom (see Figure 48a). OH: 6⅜″ (16.2 cm); acc. no. 60.516.*

Figure 36

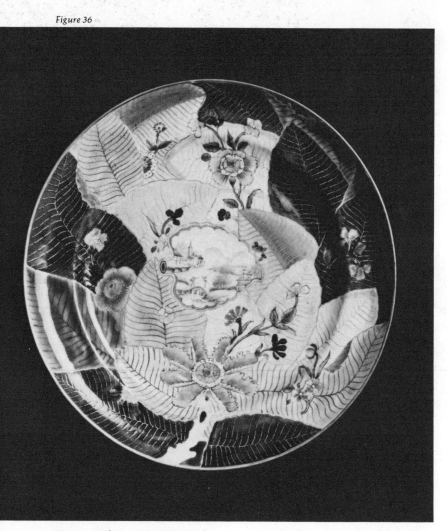

Figure 36. *Plate. 1795–1805. Such
overall designs in bright, bold colors
contrast sharply with the sparsely
decorated, monochromatic porcelains also
made around 1800. Variations of this
"tobacco leaf" pattern can be found on
export ware of the mid-18th century.
Diam: 7¾" (19.7 cm); acc. no. 66.616.17.*

Plate 5

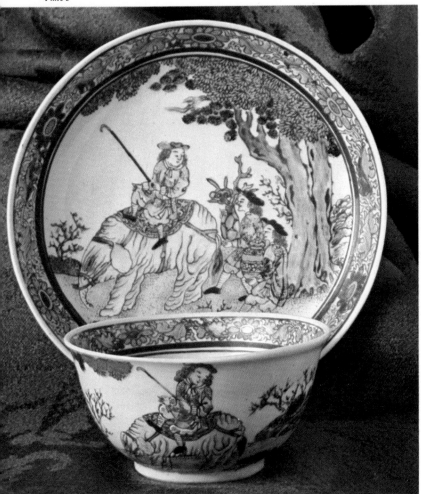

Plate 5. *Cup and Saucer. Yung-cheng.
Jewellike opaque enamels embellish this
piece of "eggshell" thinness. An early
appearance of the elephant in Chinese
art—a beast not native to China—the
scene alludes to Europe's interests in
India. Diam: 4⅝″ (11.75 cm); ex
coll. William Martin-Hurst; gift of
Charles K. Davis; acc. no. 56.46.80.*

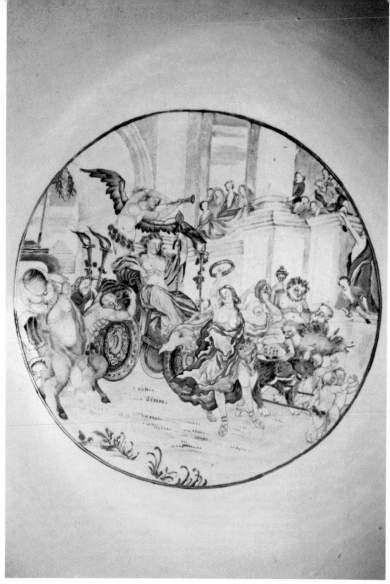

Plate 6

Plate 6. *Detail, Bowl. Ca. 1750. Themes*
from classical mythology were always popular
on China trade porcelain. This detail shows
the "Triumph of Bacchus," while the exterior
of the bowl has panels depicting Apollo, the
rape of Persephone, and Perseus slaying the
dragon. Diam: 15 9/16" (39.55 cm); acc.
no. 61.823.

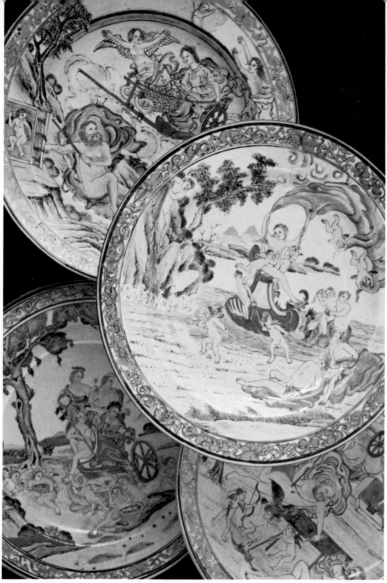

Plate 7

Plate 7. *Plates. 1730–40. These four plates depict the elements—earth, air, fire, and water—in mythological terms, as originally painted by Francesco Albani. They also demonstrate the Chinese painter's problems with the human anatomy. Diam: 9″ (22.9 cm); ex coll.*
William Martin-Hurst; gift of Charles K. Davis; acc. nos. 56.46.76.–.79.

Plate 8

Figure 37

Plate 8. *Garniture Vases. Ca. 1770. These vases illustrate the type of colorful Chinese-style objects made to European taste. OH: 11¾″ (29.85 cm); acc. nos. 59.824-.826.* **Figure 37.** *Saucer. 1815–25. The orange and gilt bird pattern is a good example of the Chinese-style designs of the 19th century. The set originally belonged to Malcolm Smith of Long Island, N.Y. Diam: 6″ (15.25 cm); acc. no. 75.130.*

Figure 38

Figure 39

Figure 38. *Vase. Ca. 1850. One of a pair,*
supposedly brought to America in 1858 by Admiral
Samuel Francis du Pont, this vase of a Rose
Mandarin *pattern illustrates the very busy*
oriental designs and harsh colors of late export
porcelain. OH: 34¼″ (87 cm); gift of Mrs. Rodney
M. Layton; acc. no. 65.96.1. **Figure 39.** *Bowl.*
Dated 1757. The Chinese painters' renditions of
oriental figures were more effective than their
attempts to depict foreigners. OH: 4½″ (11.45 cm),
Diam: 10¼″ (26.05 cm); acc. no. 64.532.

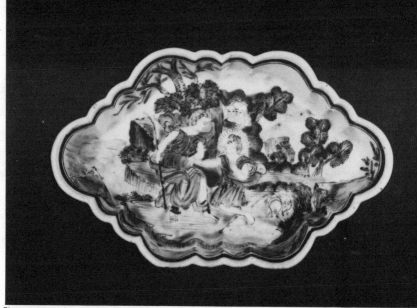

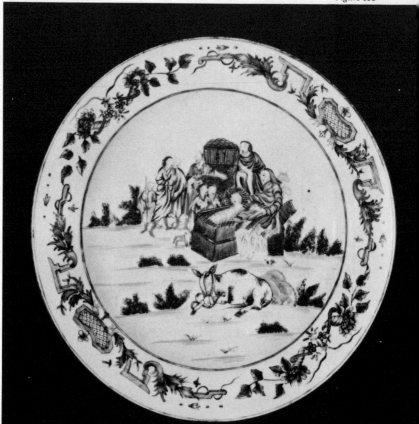

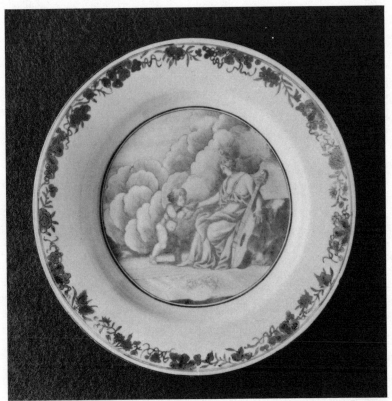

Figure 41

Figure 40a. *Spoon Tray. Ca. 1750. This unusual enameled spoon tray presents an unidentified biblical scene. OW: 5" (12.7 cm); acc. no. 65.593.*
Figure 40b. *Plate. 1735–50. The Nativity of Jesus Christ, interpreted here in polychrome, is also known in encre de chine versions. The Laub-und-Bandelwerk border was derived from a du Paquier porcelain prototype. Diam: 9⅛" (23.2 cm); gift of Charles K. Davis; acc. no. 56.46.111.*
Figure 41. *Plate. 1735–45. Delicately "penciled" in light gray encre de chine, the plate was probably intended for the Dutch market. The vine border is gilt. Diam: 9³⁄₁₆" (23.35 cm); acc. no. 56.38.71.*

Figure 42

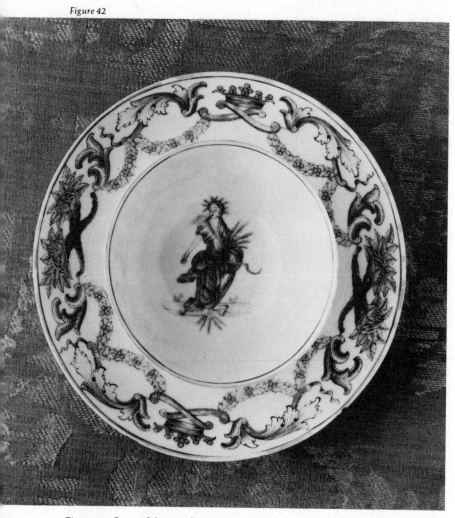

Figure 42. *Cup and Saucer. Ca. 1750.
The handleless cup and saucer each feature
the figure of Ceres painted in black and
gold. Diam (saucer): 2¾″ (7 cm); acc.
nos. 56.38.13,.14.*

Figure 43

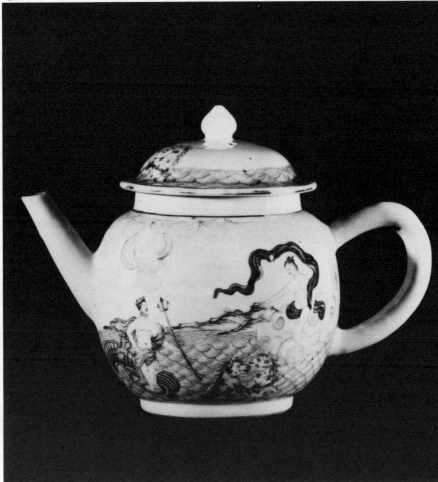

Figure 43. *Teapot. 1730–50. The western world adopted the shapes of Chinese tea vessels. The scalelike waves on which Neptune rides are painted in pale aqua. OH: 5⅛″ (13.05 cm); gift of Charles K. Davis; acc. no. 56.46.113.*

Figure 44

Figure 44. *Cup and Saucer. Ca. 1730. The
unidentified European couple is carefully painted
in* famille rose *colors on an extremely thin body.
The disparity in painting that exists between the
cup and the saucer illustrates the assembly-line
techniques of the Chinese porcelain painters. OH:
1⁷⁄₁₆″ (3.7 cm), Diam (saucer): 4½″ (11.45 cm);
ex coll. William Martin-Hurst; gift of Charles K.
Davis; acc. no. 56.46.86.* **Figure 45.** *Jardinieres.
1735–45. These extraordinary jardinieres feature two
views of Europeans at tea and four Western musicians.
Besides the usual range of "foreign" colors,
several enamels were mixed to produce unusual tones.
OH: 8⅛″ (20.7 cm), 13⅛″ square (33.35 cm);
acc. nos. 59.2893,.2894.*

Figure 45

Figure 46

Figure 47

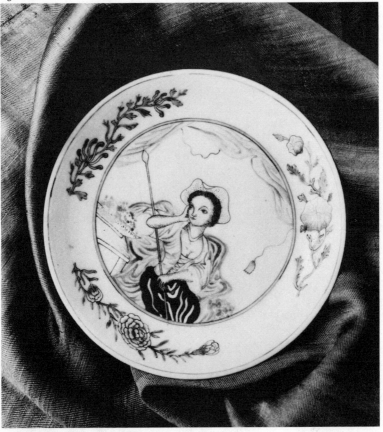

Figure 46. *Saucer. Ca. 1730. Export porcelains
are known with similar portraits entitled "Petrus de
Wolff." Pieter Schenck's mezzotint of de Wolff may
have been derived from the 1686 mezzotint of Lord
Burghley done after the painting by Willem Wissing.
Decorated with* encre de chine *in a broad washlike
manner, the saucer has a* famille rose *"surprise" on
the reverse (bottom left). Diam: 4⅝" (11.85 cm);
ex coll. William Martin-Hurst; a gift of Charkes K.
Davis; acc. no. 56.46.84.* **Figure 47.** *Saucer. 1725–35.
An aristocratic woman painted in the guise of a simple
shepherdess was a favorite conceit of baroque
portraiture. The dreamy subject of this "eggshell"-thin
saucer is thickly painted with the new colors of
Yung-cheng's reign. Diam: 4⁹⁄₁₆" (11.7 cm); acc. no.
69.1379.*

Figure 48a. *Detail, Bowl (Figure 35). 1755 – 75. The subject of the portrait has not been identified. The stippled background suggests that it was copied after a mezzotint. It is painted in colored enamels on the center bottom of the bowl and is surrounded by a bamboo border. Diam (bowl): 14⅞"-15½" (37.8 cm); acc. no. 60.516.*
Figure 48b. *Detail, Bowl. 1763 – 70. Political cartoons are not common on export porcelain. This unidentified scene in encre de chine apparently refers to John Wilkes's activities of the 1760s. (See Figures 49a and 63b for other details of this bowl.) OH: 6⅞" (17.5 cm); acc. no. 60.503.*
Figure 49a. *Detail, Bowl. The Hogarth engraving this design was taken from was*

Figure 48h

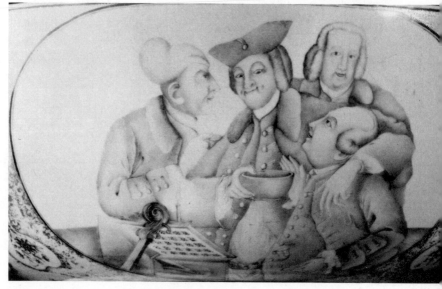

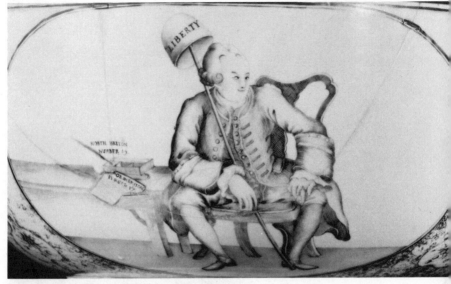

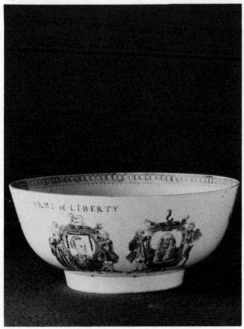

published in May, 1763, following the arrest of political radical John Wilkes (1727–97). As described in the London Chronicle, the print showed Wilkes with a liberty cap "poised over his head like a self-appointed halo, in ironic contrast to the truly diabolic squinting leer and the impression of horns created by his wig." **Figure 49b.** Bowl. Ca. 1770. On both sides of the Atlantic, "Arms of Liberty" punch bowls were for those who hailed John Wilkes as a champion of liberty. With decoration copied from a broadside issued in London, June, 1768, such bowls were ordered at a time when, according to Walpole, "the zeal of the populace heated itself to a pitch of fury." OH: 4½" (11.45 cm), Diam: 10⁵⁄₁₆" (25.4 cm); acc. no. 59.651.

Figure 50

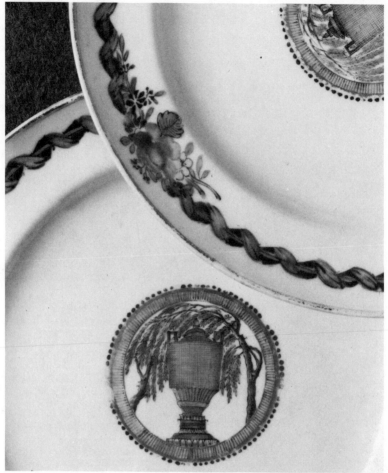

Figure 50. *Small Plates. 1793–1800.
The central decoration of these plates
was taken from an unsigned engraving
published during the French Revolution
as a royalist memorial. Entitled L'Urne
Mysterieuse, the print contained "hidden"
profile portraits of Louis XVI and Marie
Antoinette, outlined by the sides of the
urn's stem, and the faces of their
children, the Dauphin and Madame Royale,
in the branches of the flanking willows.
Diam: 6⅛″ (15.6 cm); acc. nos.
63.769.1,.2.*

Figure 51

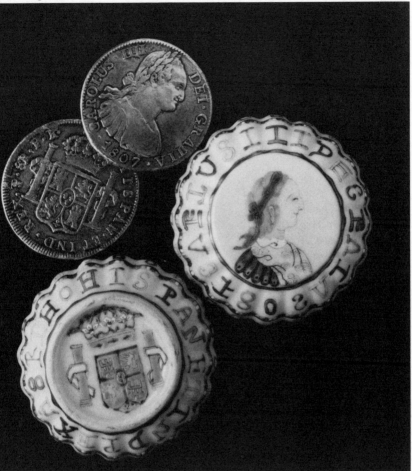

Figure 51. *Covered Box. After 1802.*
The decoration of the lid and base of
this box was copied from an 1802 Spanish
coin, similar to the one shown, with the
head of Charles IV. The irregularity of
the inscription emphasizes the painter's
inability to comprehend what he copied.
OH: 1⁵⁄₁₆″ (3.7 cm), Diam: 2³⁄₈″ (6.1
cm); acc. no. 66.592.

Figure 52

Figure 53

Figure 52. *Sugar Bowl Lid, Saucer, and Handled Cup.*
Dated 1761. These gruesome but precisely painted
encre de chine *wares were perhaps a physician's*
special order. The inscription on the underside of
the lid suggests that the service belonged to Eleun
Lira (?). The source of the anatomical details has
not been identified. OH (cup): 1″ (2.65 cm), Diam
(saucer): 2⅜″ (6.05 cm); acc. nos. 68.751.1-.3.
Figure 53. *Saucer. 1790—1820. The* encre de chine
pastoral scene on this saucer is found on services
known to have been owned by Philadelphia Quakers.
Diam: 5⁹/₁₆″ (14.1 cm); acc. no. 56.38.2.

Figure 54

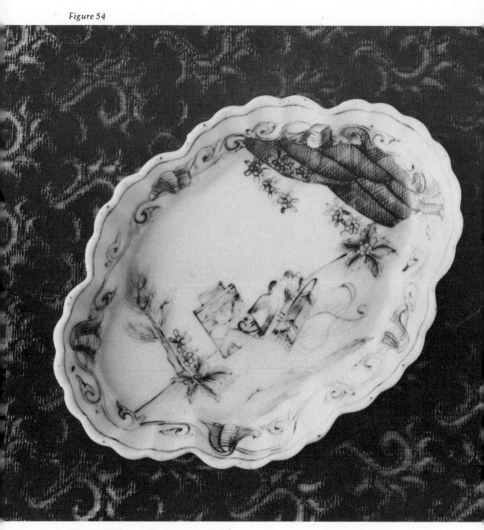

Figure 54. *Spoon Tray. 1750–60. The "Altar of Love" or "Valentine" pattern of this* encre de chine *piece was probably adapted from a drawing made by Peircy Brett while he was in Canton with his patron, Thomas Anson, in 1743. The design was later copied by English china-painters, especially at the Worcester factory. OW: 5³⁄₁₆″ (13.2 cm); acc. no. 61.893.*

Figure 55

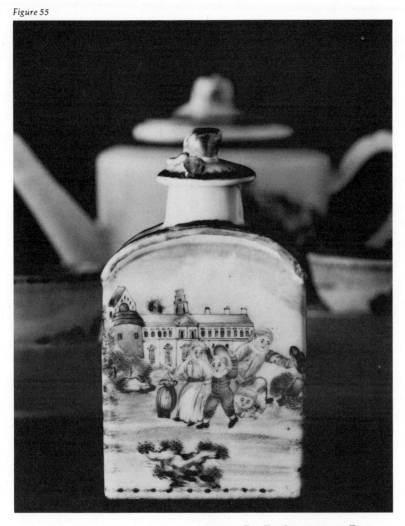

Figure 55. *Toy Tea Set. 1800 – 10. Toy tea sets for children were commonly decorated with scenes of children. This design, after an English engraving, shows children playing leapfrog. A closely related set was brought to Philadelphia from China by Henry Hollingsworth around 1800. OH (caddy): 3¹¹/₁₆″ (9.4 cm); acc. no. 66.591.1-.8.*

Figure 56

Figure 56. *Toy Cup and Saucer. 1780–1800. The
amusing "upside-down head," probably taken from an
English print, was an appropriate design for a
child's tea set. Diam (saucer):
3⅝" (9.2 cm); acc. no. 63.782.* **Figure 57.** *Jug.
1780–1800. The subject of this jug is Toby Philpot, a
character from Sterne's 1768 novel* Tristram Shandy.
*Figural "Toby" jugs were popular wares of English
potteries of the late 18th and the 19th centuries.
OH: 8⁹⁄₁₆" (21.8 cm); acc. no. 58.2953.*

Figure 57

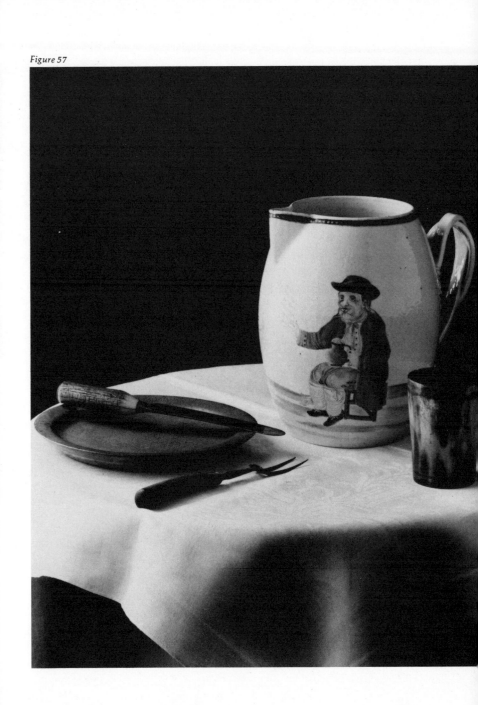

Figure 58

Figure 58. *Milk Pot, Teapot, Tray, Sucrier, and Coffeepot. 1760–75. This rare breakfast set is delicately painted with Meissen-style borders and harbor scenes. OH (coffeepot): 5″ (12.7 cm), OW (tray): 7⅜″ (18.8 cm); acc. nos. 69.1442.1-.5.*

Figure 59

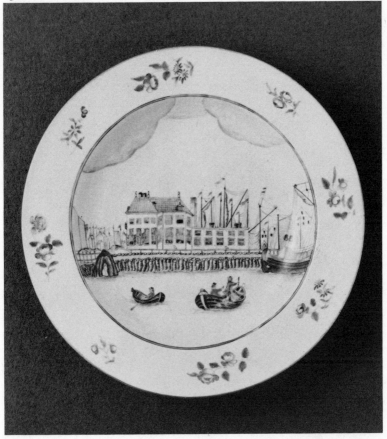

Figure 59. *Soup Plate. 1750 – 60. The subject is a popular view of the Nieuwe Stadsherberg, a public house, or tavern, on the River Y in Amsterdam. Diam: 9⅛″ (23.2 cm); acc. no. 59.2892.*

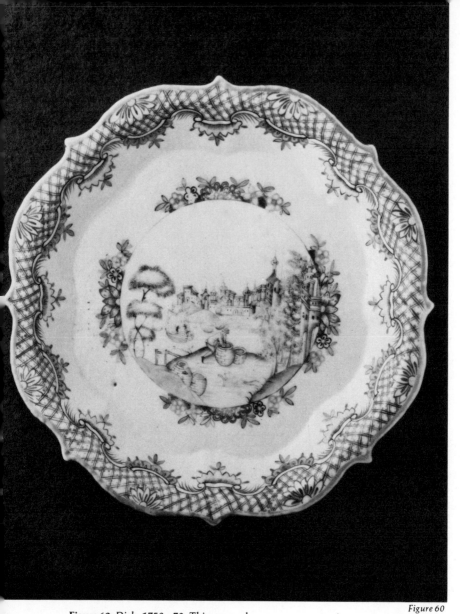

Figure 60

Figure 60. *Dish. 1750–70. This unusual
dish features a striking contrast
between the* encre de chine *harbor scene
and the bright orange red lattice border
punctuated with yellow flowers. Diam:
7¹¹/₁₆″ (19.5 cm); acc. no. 61.834.*

Figure 61

Figure 61. *Detail, Wine Cooler. 1790—1810. Harbor scenes were among the favorite subjects found on ceramics. The source for this sepia-painted view has not been identified. OH: 7⅞″ (20 cm); acc. no. 66.607.1.*

Figure 62

Figure 62. *Butter Tub and Tray. 1800–20. With its delicate gilt and sepia borders and medallion landscape scene, this service exemplifies the taste of the late neoclassical period. OW (tray): 6¼" (15.9 cm); acc. nos. 61.631.40, .41.* **Figure 63a.** *Detail, Plate. 1800–10. In the late 18th century, travel books often included engravings of individual country seats or estates. The unidentified building of this service may have been copied from such a book. OW (detail): 2¹³/₁₆" (7.2 cm); acc. no. 64.1262.6.* **Figure 63b.** *Detail, Bowl. 1763–70. The encre de chine panel may picture one of the oriental towns familiar to the China traders. It is surrounded by intricate scrollwork done in gold and flanked by pear-shaped reserve panels. OH (bowl): 6⅞" (17.5 cm); acc. no. 60.503.*

Figure 63a

Figure 63b

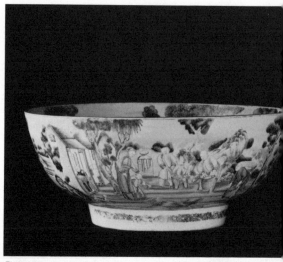

Figure 64. *Bowl.*
1755 – 75. Fox hunting was
a popular subject for
punch bowls. This is an
unusual example because
the hunt is painted on
the interior and a
rural oriental scene
covers the exterior.
Diam: 15¾″ – 16″
(40–40.6 cm); acc. no.
60.512.

Figure 64

Figure 65

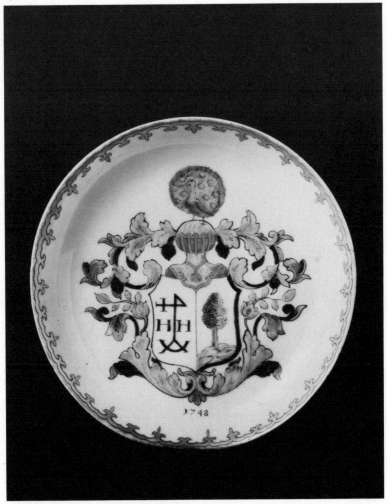

Figure 65. *Saucer. Dated 1748. Richly painted, chiefly in green and black enamels, the arms are those of Hendrik Hesselink (1723 – 80) of The Netherlands. A similar service, dated 1747, was made for Anton Hesselink. Diam: 4½″ (11.45 cm); gift of Charles K. Davis; acc. no. 56.46.83b.*

Figure 66

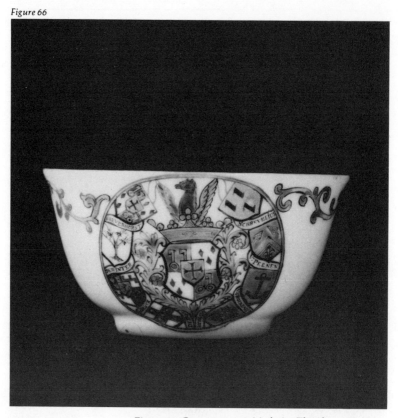

Figure 66. *Cup. 1740–50. Made for Theodorus van Reverhorst (1706–58), a member of the VOC Council of Justice at Batavia until 1752, this service is among the most elaborate of personalized porcelains of the China trade. Each piece features van Reverhorst's arms surrounded by those of each of his eight great-grandparents: van Reverhorst, Vereyck, de Winter, de Bruyn, Schrevelius, van Groenendyk, van Peenen, and de Vroede. OH: 1¼" (3.2 cm); gift of Charles K. Davis; acc. no. 56.46.107a.* **Figure 67.** *Detail, Tea Caddy. 1750–60. Only a few Chinese porcelains are known that bear the royal arms of England. The form of this tea container and its simple spearhead border suggest that it was made during the reign of George II, but not for the royal family. OH (without lid): 4¼" (10.8 cm); ex coll. William Martin-Hurst; gift of Charles K. Davis; acc. no. 56.46.71.*

Figure 67

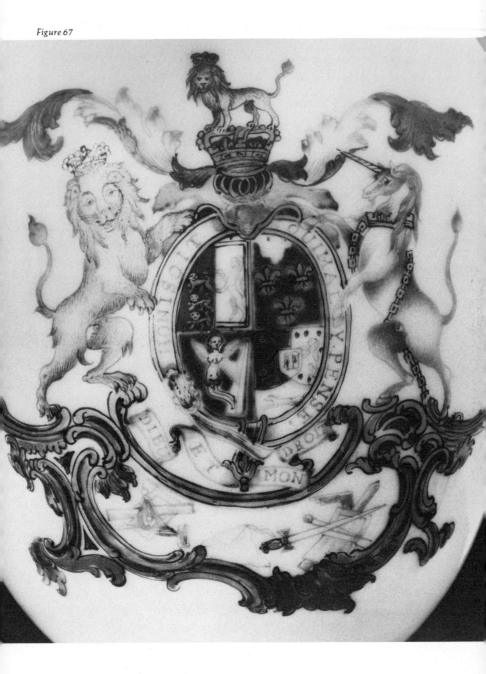

Figure 68

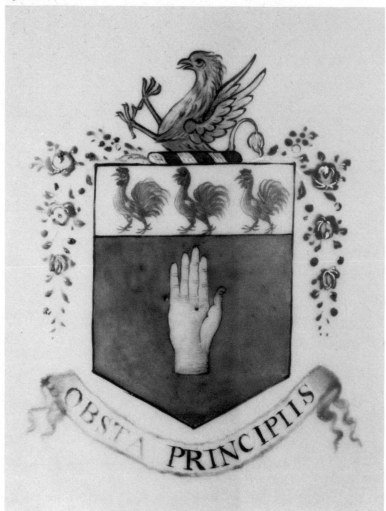

Figure 68. *Detail, Mug. Ca. 1790. Although the same arms were used by John Hancock, it is very possible that this piece was ordered by his English relations who were involved in the China trade. OH (mug): 4¹³⁄₁₆″ (12.2 cm); acc. no. 56.547.*

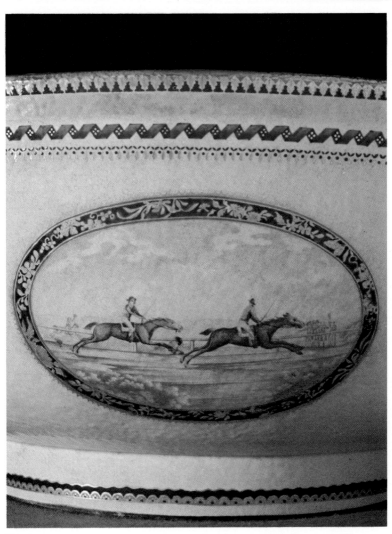

Plate 9. *Detail, Bowl. Ca. 1780. This unusual vignette—duplicated on a bowl originally made for John Seawell of Gloucester County, Va.—is one of four on the exterior of an immense punch bowl. The other medallions contain a deer, dog, and dog and hare. Hunters no doubt enjoyed draining the contents of the bowl to find the fox painted on the center bottom. Diam: 22⅛″ (56.2 cm); acc. no. 60.1018.*

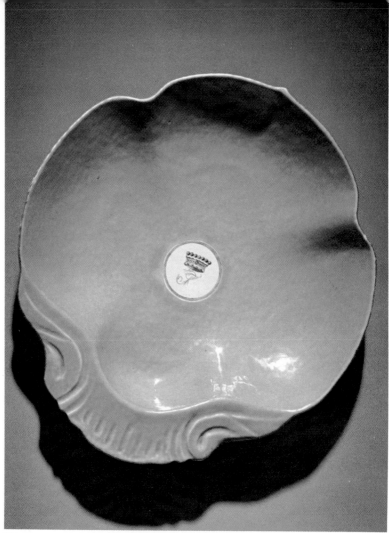

Plate 10

Plate 10. *Dish 1795 – 1815. Made for an unidentified customer, probably on the Continent, this dessert service is distinguished by its rich turquoise glaze. OL: 10⁷/₁₆″ (26.5 cm); acc. no. 66.615.28.* **Plate 11.** *Covered Dish, Covered Bowl, and Plate. 1800 – 10. Some of the most brilliantly colored export porcelains were sent to Portugal. Don Antonio Jose de Castro, Bishop of Oporto between 1789 and 1814, owned these examples. OH (dish): 9¼″ (23.5 cm); acc. no. 66.570.1-.3.*

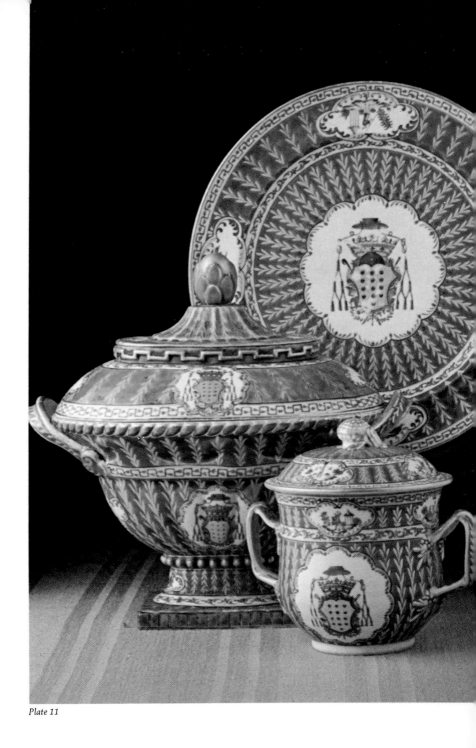

Plate 11

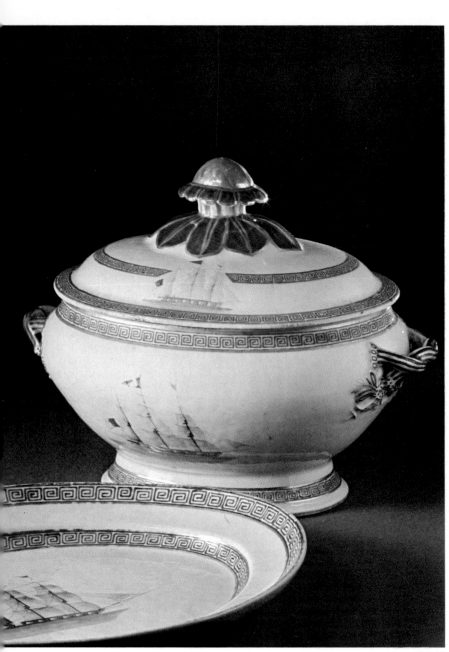

Plate 12

Figure 69

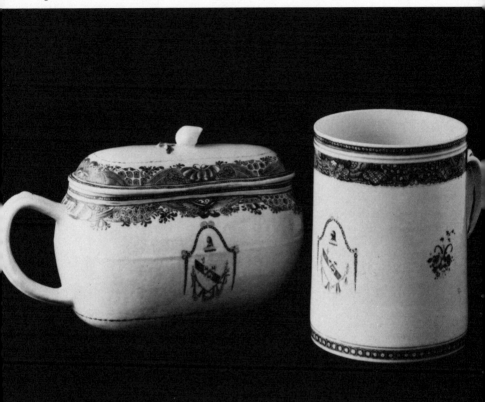

Plate 12. *Tureen and Stand. Ca. 1800 (possibly ca. 1840). Miguel Antonio Souza, a Portuguese merchant based in Macao, owned the ship* Brilliante *that is painted on each piece of the service. According to family tradition, the service was not used by Souza but was ordered by his granddaughter and her husband in his honor. OH: 11⅞″ (30.15 cm); acc. no. 60.326.35a-c.* **Figure 69.** *Bourdalou and Mug. Ca. 1785. Sir William Dalling of Orval, Surrey, probably ordered this service during his 18-month appointment as commander in chief of Madras. While the borders of the mugs, chamberpots, and saucers in the Winterthur collection are painted in underglaze blue, those of the three bourdalous are in overglaze blue enamels, suggesting that these were undecorated stock at Canton and were painted there to match the other pieces. OH (mug): 6⅛″ (15.6 cm), OW (bourdalou): 9¾″ (24.8 cm); acc. nos. 60.803.1; 60.1196.1.*

Figure 70b

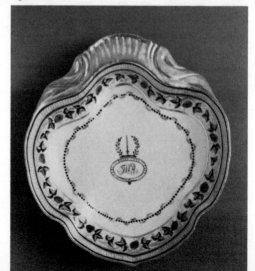

Figure 71

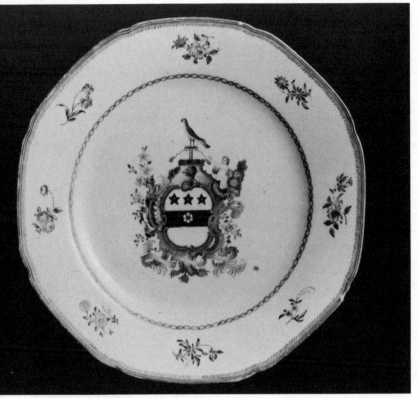

Figure 70a. *Platter. Ca. 1780. The platter is part of a service made for a Portuguese official in Brazil, Francisco Antonio da Veiga Cabral Pimental, first viscount of Mirandela. OW: 9⁹⁄₁₆" (24.3 cm); gift of Charles K. Davis; acc. no. 56.46.57.*
Figure 70b. *Dish. Ca. 1800. This shell-shaped dish is part of a service made for a member, "JWA," of the Anderson family of Tushielaw in Stirlingshire, Scotland. Its grapevine borders are painted in shades of blue and gold. OH: 1¾" (4.5 cm), OD: 10⅜" (26.4 cm); acc. no. 66.1104.5.* **Figure 71.** *Plate. 1785–90. This piece is part of a service probably ordered by Justice Samuel Chase (1741–1811) of Annapolis, Md. The enamel-painted arms are those of his aunt, Margaret Townley, but Chase's bookplate proves that he used the same arms. OW: 8¹⁵⁄₁₆" (22.7 cm), OD: 9¹⁄₁₆" (23 cm); acc. no. 71.721.*

Figure 72

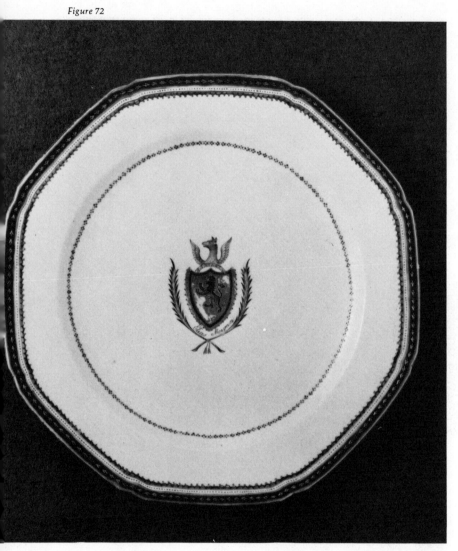

Figure 72. *Plate. 1790–1800. The plate is from one of the very few armorial services designed for an American. The original owner, Elias Morgan, of Connecticut, had his name added beneath a variant of the registered Morgan arms. OW: 9⅜″ (23.8 cm); acc. no. 56.46.49.*

Figure 73a

Figure 73a. *Detail, Bowl (see Figure 39). Dated 1757. Those who were not entitled to heraldic bearings sometimes designed their own coats of arms and crests. Coats of arms were often composed of rebuses of the family name (Fig. 68), so Jacob Harrington Cooper's choice of cooper's barrels is not surprising. OH: 4½" (11.45 cm); acc. no. 64.532.*
Figure 73b. *Detail, Covered Bowl (see Figure 74). Dated 1762. The joined ciphers probably commemorate a marriage. Acc. no. 61.889.*

Figure 73b

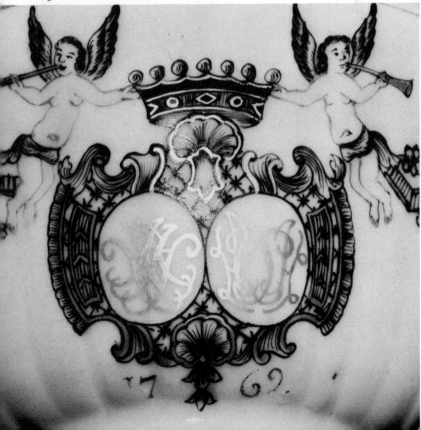

Figure 74

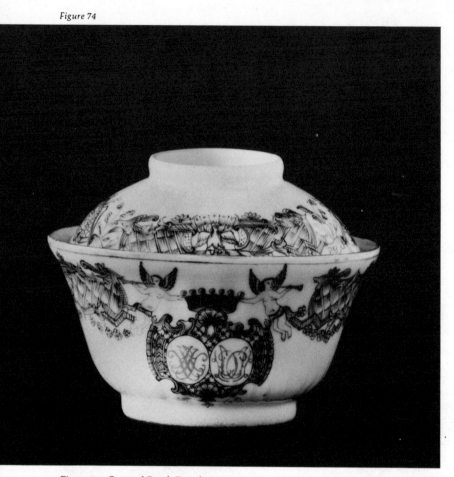

Figure 74. *Covered Bowl. Dated 1762.*
Of Chinese form, covered bowls like
this were adopted by Westerners for
sugar. This is a useful document for
the dating of related encre de chine
pieces. OH: 3½" (8.9 cm); acc. no.
61.888,.889.

Figure 75

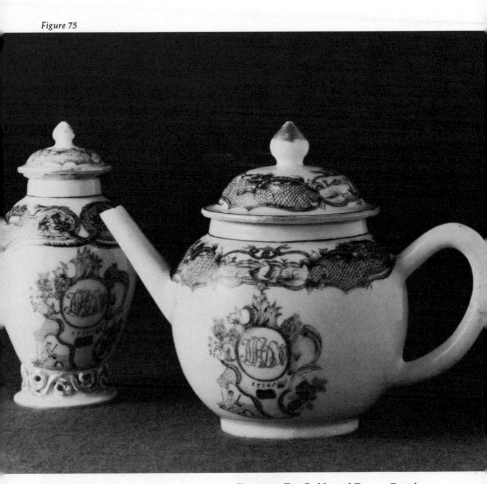

Figure 75. *Tea Caddy and Teapot. Dated 1756. This dated tea set presents an unusual combination of typical* encre de chine *borders and a rococo-style cartouche in* famille rose *enamels. OH (tea caddy): 5⅛″ (13.05 cm), OW (teapot): 7¼″ (18.45 cm); gift of Charles K. Davis; acc. no. 56.46.88,.90.*

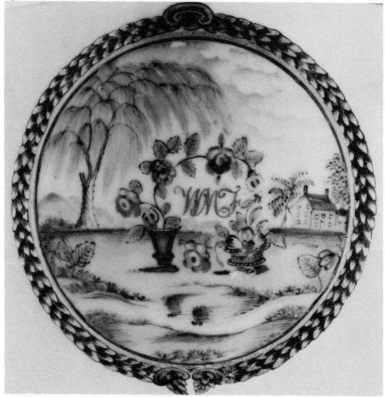

Figure 76a. *Detail Bowl.
1810–20. The striking
placement of pink flower
arrangements within a
chartreuse landscape is
unusual and was perhaps
painted to the
specifications of "WMF."
OH (bowl): 3⅜" (8.6 cm);
acc. no. 61.1028.*
Figure 76b. *Detail, Handled
Cup. 1800–10. This
personalized service, of
which Winterthur owns 129
pieces, was skillfully
decorated in orange, brown,
and gilt. OH (cup):
2⅝" (6.7 cm); acc. no.
63.747.24.*

Figure 77. *Bottles. 1830−50. Two remarkable
bottles, each with "Huffnagle" painted on the base
in red enamel, were probably owned by Dr. Charles
Huffnagle (1808−60). An American physician,
Huffnagle became an agent of the British East India
Company. In 1847, he was appointed first U.S.
Consul at Calcutta and, in 1855, became the
American Consul to British India. When he returned
to America in 1857, he brought with him his vast
collection of oriental art objects and exhibited
them to the public at his home, "Springdale," in
Bucks County, Penn. OH: 12¹³⁄₁₆″ (32.6 cm); acc.
nos. 63.941.1,.2.*

Figure 78

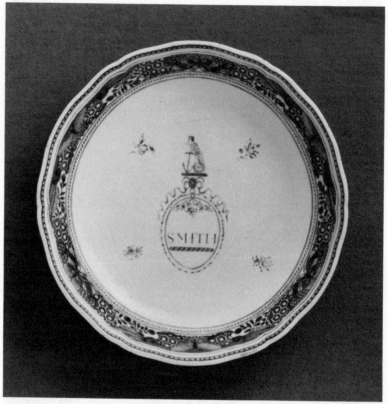

Figure 78. *Dish. 1780—85. The figure of Hope was a popular neoclassical device and not a registered crest for a Smith family. The blue Fitzhugh-style border is combined with an enameled wavy band and central decorations. Diam: 8⁵⁄₁₆″ (21.1 cm); acc. no. 56.38.69.* **Figure 79.** *Bowl and Mugs. 1790—1800. Freemasons would have ordered these porcelains, painted with the symbols of the brotherhood. OH (tallest mug): 5⁷⁄₁₆″ (13.8 cm); acc. nos. 56.555; 56.557; 67.581.*

Figure 79

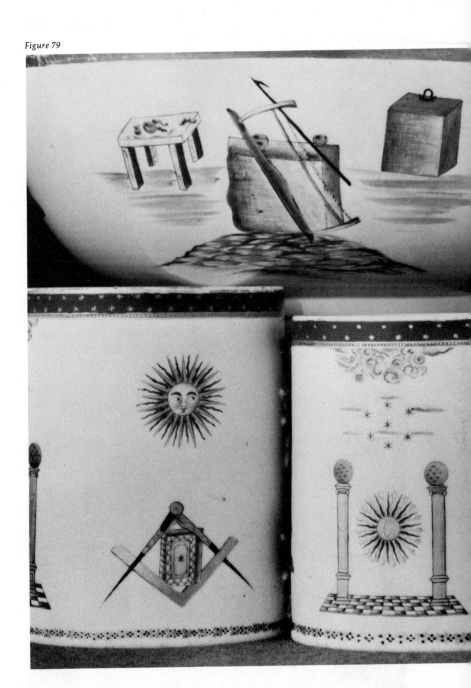

Figure 80. *Cup and Saucer. Ca. 1760. Four export porcelain services are known to have been made for the "Noble Order of Bucks," an English society that flourished in the 18th century (see song, right). The enameled decoration was copied from John Sadler's 1757 print of the Society's arms, which the Chinese painter split, putting the crest on the cup and the rest of the design on the saucer. OH (cup): 1¾" (4.5 cm); gift of Charles K. Davis, acc. no. 56.46.87; 69.1772.*

Figure 80

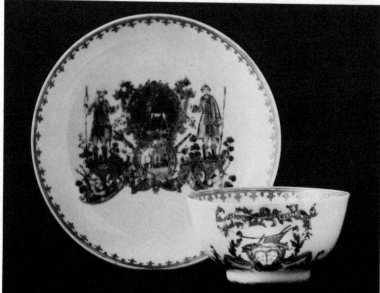

Figure 81

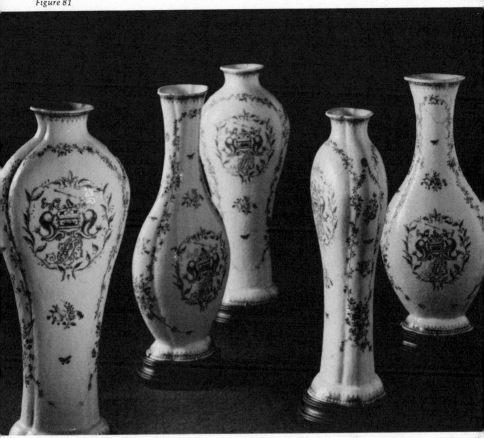

Figure 81. *Garniture. Ca. 1770.*
Painted with the arms of the Watermen
and Lightermen's Company of London,
this garniture was perhaps a gift to
the Company from one of its officials,
"TLB." OH (with base): 12⅝″
(32.1 cm); acc. no. 59.2895 – .2899.

Figure 82

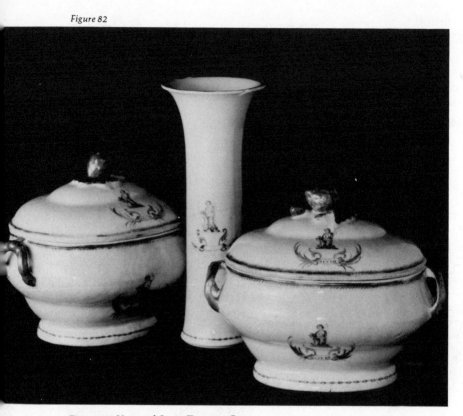

Figure 82. *Vase and Sauce Tureens. Ca.
1786. These pieces were very likely
part of the 272-piece "ciphered" service
that Elias Hasket Derby of Salem, Mass.,
purchased from the cargo of the* Grand
Turk *in 1786—87. Derby financed the*
Grand Turk, *one of the first American
ships to enter the China trade. OH
(vase): 7⅝″ (19.4 cm); acc. nos.
56.550.1,.2; 56.38.28.*

Figure 83

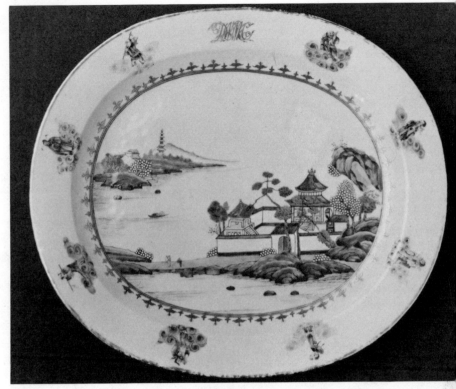

Figure 83. *Platter. 1796–1810. This polychrome platter was made for New York politician De Witt Clinton and his wife Maria. With its figures painted on the rim, it demonstrates the beginning of the so-called Mandarin taste in export ware. OW: 15½" (39.35 cm); acc. no. 56.21.*

Figure 84. *Tea Service. 1795–1810. This unique service, painted with the state arms of New Hampshire, was made for John A. Colby of Concord, N.H. The accompanying bill shows that the 53 pieces, of which Winterthur has 28, were obtained through the merchant Yam Shinqua at Canton. OH (cup): 1⅛" (4.8 cm); ex coll. Mrs. Francis Crowninshield; acc. no. 60.7.6,.26–28; manuscript bill, 58 x 33, Winterthur Museum Library.*

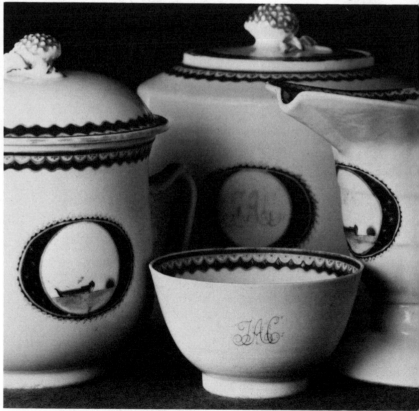

For Mr John Colby New Concord 53 p

Yam Shinqua
China Ware Merchant
at Cantone.
All sorts of Chinaware. Arms &c.ª
Painted on the most reasonable Term

Figure 84

Plate 13

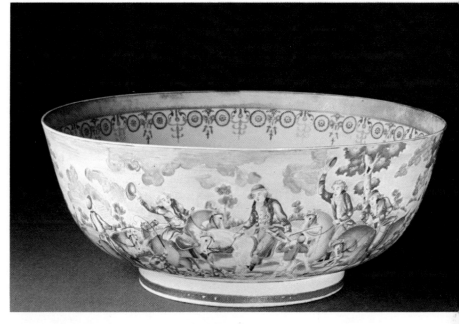

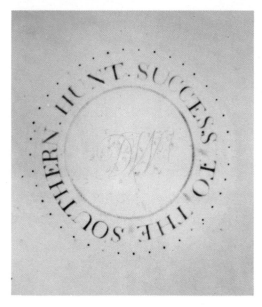

Plate 13. *Bowl and Detail. 1800—10. Fox hunting had been popular in the American South since colonial days, and several export hunt bowls are known that have Southern histories. "DW" was probably the master of the "southern hunt" for which this bowl was made. Diam: 15⁹⁄₁₆″ — 15¾″ (39.5—40 cm); acc. no. 75.41.*

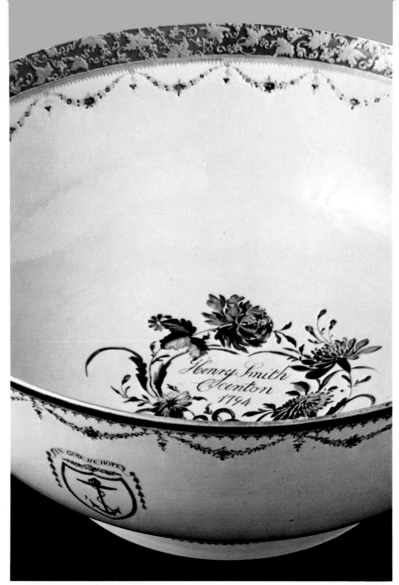

Plate 14

Plate 14. *Bowl. Dated 1794. Henry
Smith no doubt purchased this bowl while
in Canton in 1794 as supercargo of the
George Washington. The ship was one of
several out of Providence, R.I., that
were named for the first president. Diam:
16″ (40.6 cm); acc. no. 59.149.*

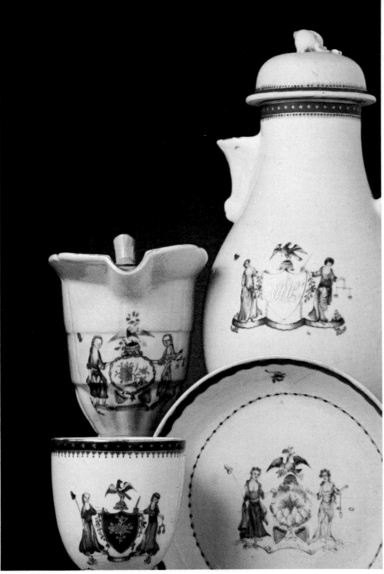

Plate 15

Plate 15. *Handled Cup, Cream Jug, Saucer, and Chocolate Pot. 1785–1805. Only the saucer has the full coat of arms of New York. The other pieces show Justice and Liberty, but the shields they hold contain flowers or initials. OH (pot): 8⅜″ (21.3 cm); gift of Charles K. Davis, acc. no. 56.46.105; 63.815.2; ex coll. Stanley S. Wohl and Guy W. Walker, 58.135.10b; 63.812.*

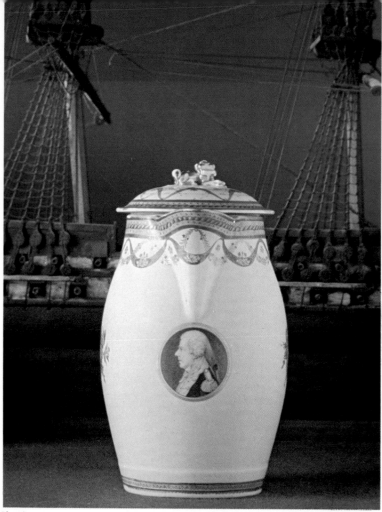

Plate 16

Plate 16. *Jug. Ca. 1805. Decorating this handsome jug is an astonishing likeness of Stephen Decatur, Sr., (1752–1808), painted after the Saint-Mémin engraving of 1802. An identical portrait medallion appears on a bowl that commemorates Capt. Decatur's capture of the French vessel,* Incroyable, *in 1798. OH: 11″ (27.95 cm); acc. no. 56.549.* **Figure 85a.** *Handled Cup and Saucer. 1800–15. This set, with its handsome classical border in black and sepia, has the initials of Mary Lavinia Rodney Fisher of Delaware. Diam (saucer): 5¼″ (13.4 cm); acc. no. 56.38.22,.24.* **Figure 85b.** *Dish. Dated 1793. This simple piece has the interesting inscription "New York/1793" and was owned by "AL," possibly a member of the Livingston family of New York. The decoration is entirely gilt. Diam: 7⅞″ (20 cm); acc. no. 57.25.*

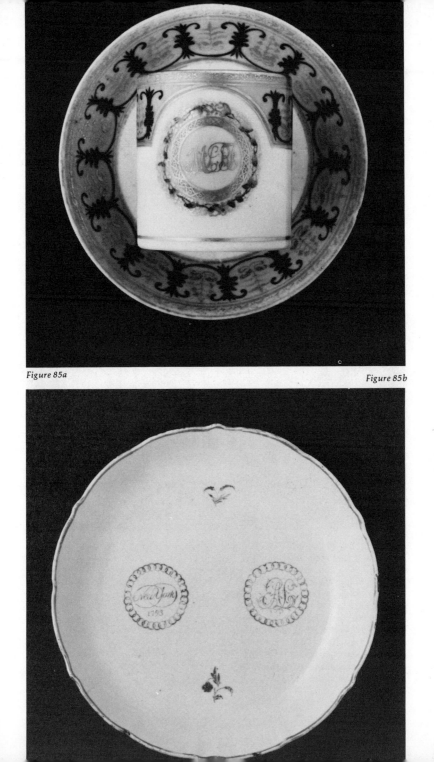

Figure 86

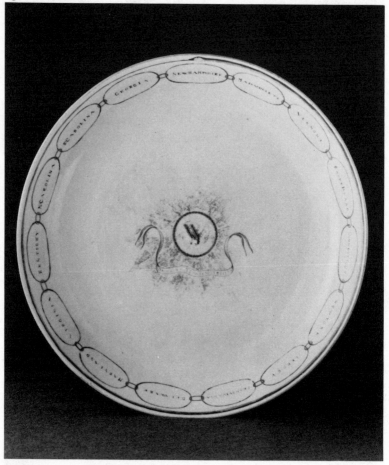

Figure 86. *Cake Plate. Ca. 1795. The
cake plate is part of the important tea
service given to Martha Washington by
A. E. van Braam Houckgeest, a Dutch
merchant, when he returned from China
in 1796. Each link of the border chain
contains the name of a state; a serpent
biting its tail, symbolizing eternity,
surrounds the chain. The owner's
initials are shown against the
now-faded rays of the rising sun of the
Republic. Diam: 13⅞" (35.3 cm);
acc. no. 63.705.*

Figure 87

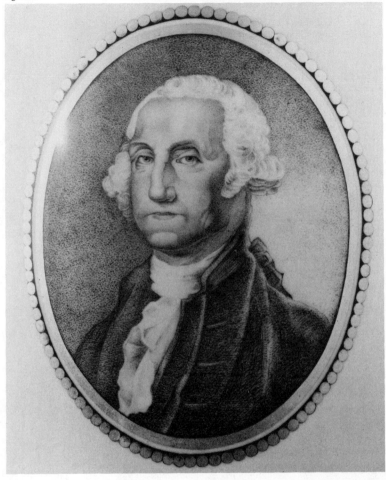

Figure 87. *Detail, Jug. 1810–20.*
This detail attests to the
extraordinary skill of the Chinese
copyist in reproducing David Edwin's
engraving of George Washington, after
a painting by Gilbert Stuart. Benjamin
Chew Wilcocks, Philadelphia merchant
and American consul at Canton between
1814 and 1828, gave this jug and its
mate to his nephew Edward Tilghman. OH
(detail): 5½" (14 cm); acc. no. 63.822.

Figure 88a

Figure 88a. *Detail,
Teapot. 1805 – 15. The
stylized view of Mount
Vernon is one of the few
identified American
landscapes on Chinese
export porcelain. Diam
(detail): 2″ (5.1 cm);
acc. no. 56.38.42.*
Figure 88b. *Covered Custard
Cups. 1800 – 10.
Handsomely painted in
sepia, brown, and gilt,
these cups feature a
memorial to Washington, who
died in 1799. OH: 3½″
(8.9 cm); acc. nos.
63.966.5,.6.*

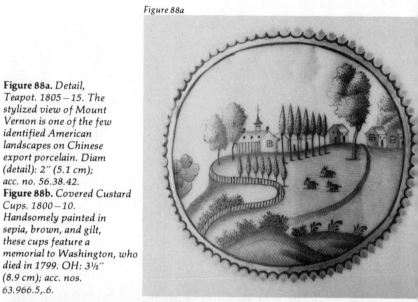

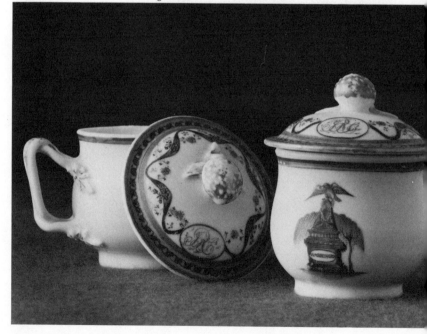

Figure 88b

Figure 89

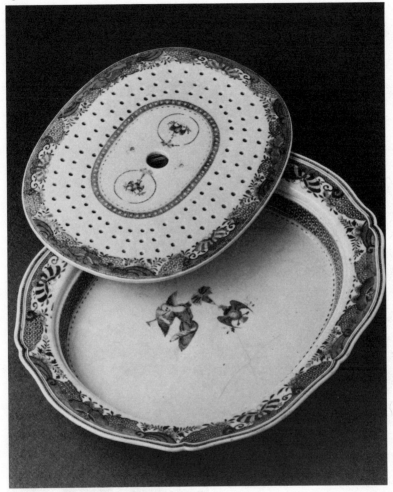

Figure 89. *Serving Dish and Strainer. Ca. 1785. In 1786, George Washington purchased, for $150, three hundred and six pieces of blue and white china painted with the badge of the Order of the Cincinnati. Washington and Colonel "Light-Horse Harry" Lee apparently had identical services, both of which descended in the Lee family. Sixty-six pieces are at Winterthur. OW: 16³/₁₆" (41.1 cm); acc. nos. 63.700.51,.52.*

Figure 90

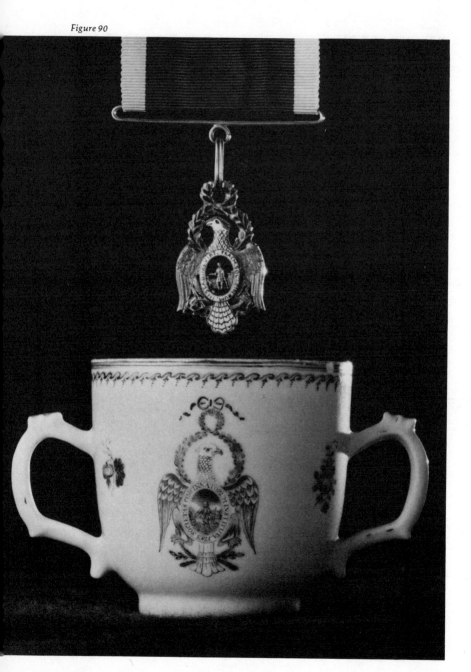

Figure 91

Figure 90. *Two-Handled Cup and Badge of the Order of the Cincinnati. 1785 – 90. According to Samuel Shaw, the original owner of this cup, the china-painter at Canton could copy a single emblem of the Order of the Cincinnati but was unable to combine them in the grouping Shaw wished. Shaw supplied the painter with engravings. OH: 2⅝" (6.7 cm); ex coll. Edmund Quincey, acc. no. 53.166.1; badge, acc. no. 63.824.* **Figure 91.** *Jug and Mugs. 1795 – 1815. These wares exhibit some of the best-painted and most handsome eagles found on American-market export ware. Canton enamelers could have copied the bird from coins or official documents. OH (jug): 10" (25.4 cm); acc. nos. 61.665; 61.666.1-.9.*

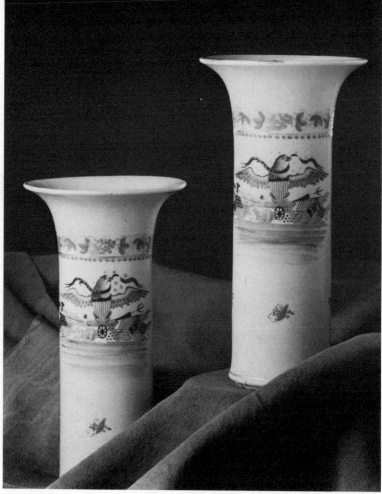

Figure 92

Figure 92. *Vases. 1800—15. The garniture vases show the same boldly colored eagles and trophies of war as the reverse of Figure 97. They relate to a service made for the Nichols family of Salem. Thanks to the Chinese painter, these eagles will forever carry the banner, "E RLUPIB UMUM." OH: 10" (25.4 cm); acc. no. 63.710.1,.2.* **Figure 93.** *Details of Eagle-Decorated Porcelain. 1790—1820. These illustrate some of the variations of the national symbol that can be seen on American-market porcelain. There were few attempts to produce the "official" version; indeed, as one writer has said, some Chinese renditions more closely resemble "an English sparrow than the fowl of freedom." Acc. nos. 63.759b; 63.727.27; 56.46.61.*

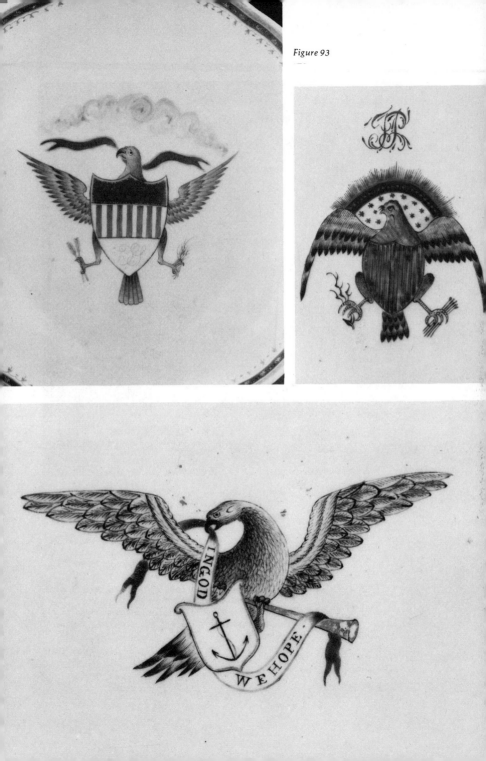

Figure 93

Figure 94

Figure 94. *Sauce Tureen, Platter, and Salad Bowl. 1800–10. The tureen and platter are in green, the bowl in orange, "Fitzhugh" patterns, combined with impressive spread eagles. The elements of the pattern are first seen in the 1760s. A later service owned by the FitzHugh family adapted the design and gave the style its popular name. OW (platter): 16⅛" (40.9 cm); acc. nos. 56.548.22,.23; 68.515.*
Figure 95. *Coffeepot. 1800–10. The sepia-colored eagle is unusually confined within a double polychrome wreath. The set originally belonged to Sarah Russell of Nantucket. OH: 7½" (19.1 cm); acc. no. 63 734.2.*

Figure 95

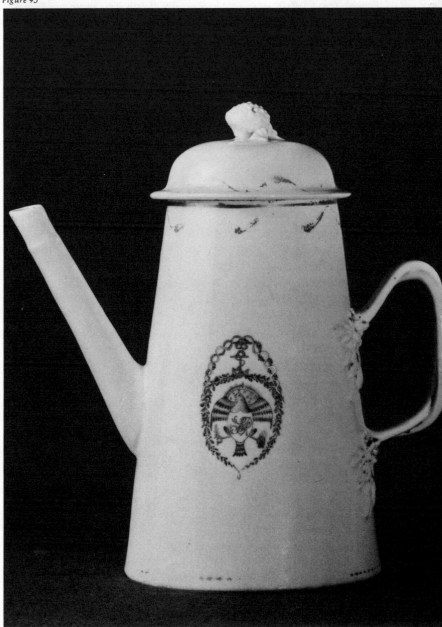

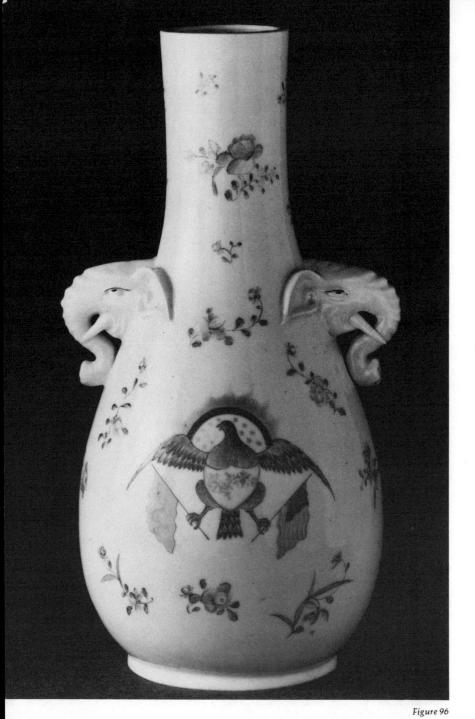

Figure 96

Figure 97

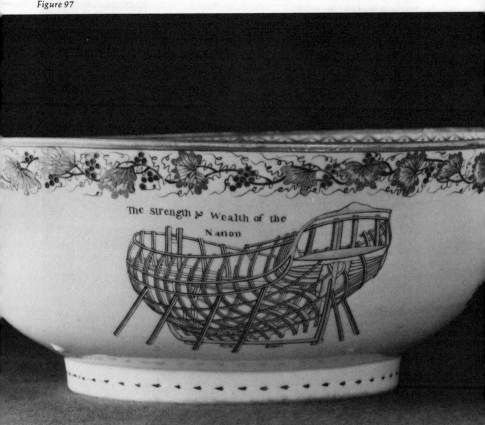

The Strength & Wealth of the
Nanon

Figure 96. *Bottle. Ca. 1844. The American eagle clutching the flags of China and the United States suggests that this piece was made to commemorate the 1844 Treaty of Wanghia, which opened five more ports to American trade. The pale, languid flower sprays support an 1840s date. OH: 12¼" (31.1 cm); acc. no. 66.641.* **Figure 97.** *Bowl. 1800—15. Shipbuilding was indeed the "strength & wealth of the Nanon [Nation]" in the burgeoning years of the China trade. The reverse features an eagle like that on the vases of Figure 92. Diam: 11⅛"—11⁷/₁₆" (28.3—29.1 cm); acc. no. 57.63.*

Figure 98

Figure 99

Figure 98. *Jug. Ca. 1815. This marvelously
painted jug depicts two naval battles of the War of
1812: the encounter of the frigates* United States
and Macedonian *on October 25, 1812, and the clash
of the brigs* Enterprise *and* Boxer *on September 5,
1813. Capt. James Lawrence's immortal words are
displayed beneath the spout (left). OH: 11¼"
(28.6 cm); ex coll. J. Kenneth Danby; acc. no.
56.38.41.* **Figure 99.** *Sauceboat and Leaf Dish.
1820–40. The 240-ton steamer* Philadelphia, *of the
Union Line, plied the Chesapeake Bay from Baltimore
to Frenchtown. Built in 1816, it operated until 1841.
Each of the several pieces of this set has a thickly
painted blue enamel border. OW (sauceboat): 7³⁄₁₆"
(18.3 cm); acc. nos. 63.706.1,.2.*

Figure 100

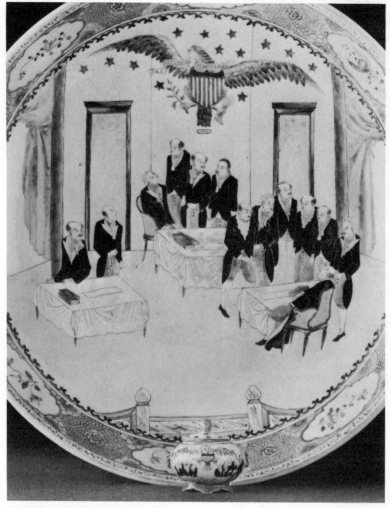

Figure 100. *Dish and Miniature Tureen.
Ca. 1876. The scene painted on each of
these pieces is the signing of the
Declaration of Independence. The
fathers of the country have been
"Orientalized." Porcelains with this
ambitious design were first made around
1840. OH (tureen): 2⅛" (5.4 cm),
Diam (dish): 14½" (36.8 cm); acc.
nos. 66.662; 66.652.*